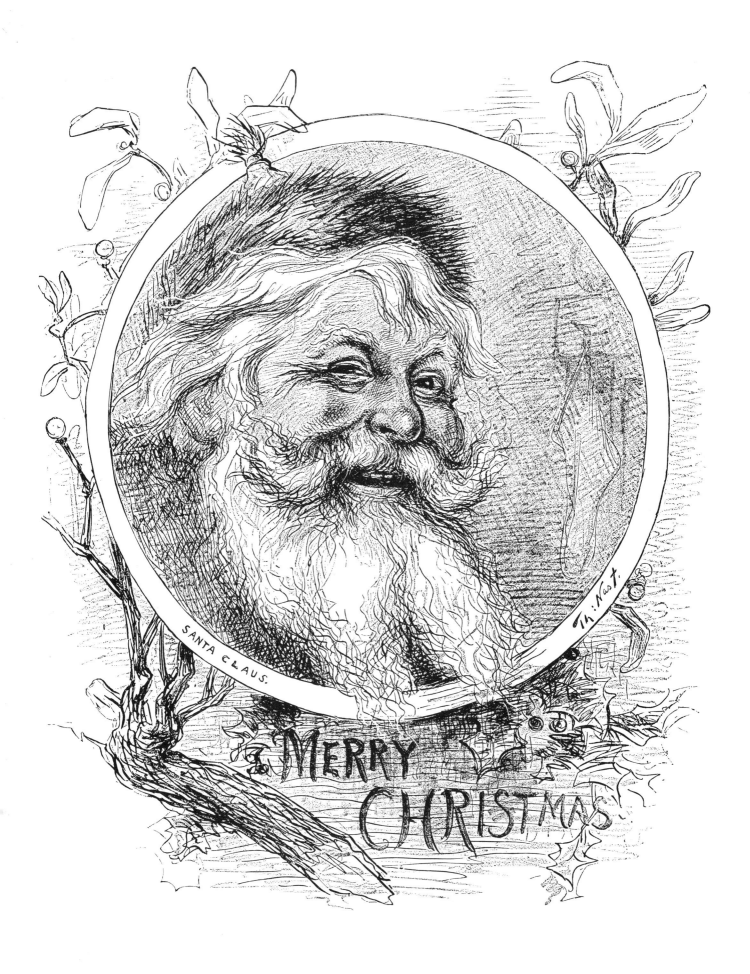

SANTA CLAUS.

Th: Nast.

MERRY CHRISTMAS

THOMAS NAST'S
CHRISTMAS DRAWINGS

by
THOMAS NAST

With an Introduction by
Thomas Nast St. Hill

Dover Publications, Inc.
New York

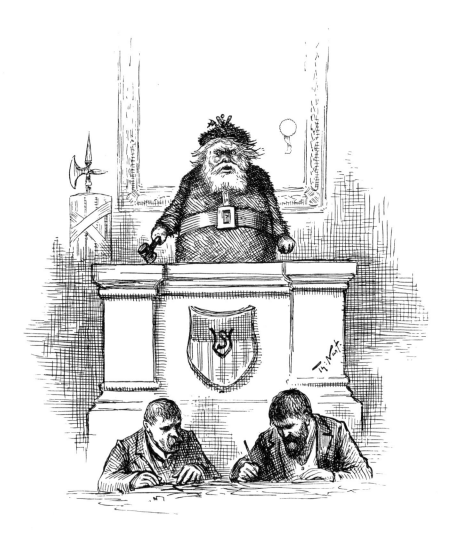

Published in Canada by General Publishing Company, Ltd., 30 Lesmill Road, Don Mills, Toronto, Ontario.

Published in the United Kingdom by Constable and Company, Ltd., 10 Orange Street, London WC2H 7EG.

This Dover edition, first published in 1978, is an unabridged republication of the work originally published by Harper & Brothers, New York, in 1890 under the title *Thomas Nast's Christmas Drawings for the Human Race*. Three black-and-white illustrations have been added to the collection: p. 21 (from *Harper's Weekly*, December 30, 1865); p. 48 (from *Hearth and Home*, December 26, 1868); p. 44 (from "A Visit from St. Nicholas" in *Christmas Poems*, 1863-64). The color illustrations reproduced on the inside and back covers are from *Santa Claus and His Works* by George P. Webster, published by McLoughlin Brothers, New York, ca. 1869.

A new introduction has been written especially for this edition by Thomas Nast St. Hill, grandson of the artist.

International Standard Book Number: 0-486-23660-9
Library of Congress Catalog Card Number: 78-52251

Manufactured in the United States of America
Dover Publications, Inc.
180 Varick Street
New York, N.Y. 10014

INTRODUCTION

Thomas Nast, America's foremost political cartoonist and the creator of the image of Santa Claus as we recognize him today, was born in 1840 in the military barracks in Landau in the Palatinate, Germany, where his father was a musician in the Ninth Regiment Bavarian Band. In 1846 the elder Nast sent his wife and family to the United States. He joined them four years later, finding employment in New York in the orchestra of Burton's Theatre on Chambers Street and as a member of the Philharmonic Society.

Young Thomas' education in public school lasted only six years. When it became obvious that his sole interest was in drawing he was transferred to an art school, but his father's limited income could not keep him there long. Obliged to seek employment at the age of fifteen, young Nast found himself in front of Frank Leslie, owner of *Leslie's Illustrated,* one of the most popular journals of the time. To discourage the would-be artist, Leslie gave him an assignment that he thought was quite beyond the youngster's capabilities—to sketch the crowd at the Christopher Street Ferry at the last call of "All Aboard!" But the work submitted so impressed Leslie that he hired Nast. While on the staff of *Leslie's* the young artist acquired priceless instruction from some of the finest illustrators of the period. He also studied the works of the English artists John Gilbert, John Leech and John Tenniel, whose career with *Punch* was then in its ascendency. During these years Nast drew his first cartoons attacking civic dishonesty.

When financial problems forced *Leslie's* to cut back its staff, Nast left the paper to free-lance. In 1859 *Harper's Weekly* accepted a full-page drawing by him exposing a police scandal. This marked the beginning of an association with the publication that lasted until 1886.

In 1860, the twenty-year-old Nast sailed for England to cover the Heenan-Sayers championship heavyweight fight for the *New York Illustrated News*. While abroad he learned of Giuseppe Garibaldi's return from exile in South America to liberate his native Italy from Austrian domination. Garibaldi was the type of crusader that appealed to Thomas Nast so upon completion of his prizefight assignment he joined Garibaldi as war correspondent, sending his sketches to the *London News* as well as the *New York Illustrated News*. Nast served throughout Garibaldi's successful campaign and sailed for home in early 1861. On the day before his twenty-first birthday he married Sarah Edwards, a cultured young lady of English parentage whom he had courted prior to going abroad. The marriage, which lasted until Nast's death, was an extremely happy one.

Nast joined the staff of *Harper's Weekly* as a war correspondent in 1862 and attained national recognition for his coverage of the Civil War. While most of his drawings depicted actual scenes at the front, it was his emotional emblematic cartoons that aroused patriotic fervor and captured the imagination of the country. President Lincoln referred to him as the Union's best recruiting sergeant and at the close of the war General Grant said that Thomas Nast had done as much as any one man to preserve the Union and bring the war to an end—a remarkable tribute to the young German-born artist.

With his reputation well established, Nast's career continued to flourish. His most famous campaign was perhaps that against the corrupt ring headed by "Boss" William Marcy Tweed that was bleeding the New York City treasury dry. Because of his scathing cartoons pressure was brought to bear on Nast and *Harper's* by the Tweed Ring. Tweed did not so much care what the papers printed about him, he said, because most of his constituents couldn't read, but they could understand "them damn pictures." But with the support of Fletcher Harper, Nast continued his attacks, despite threats on his life, and succeeded in putting Tweed behind bars. When Tweed died in New York's Ludlow Street jail in 1878, every one of Nast's cartoons attacking him was found among his effects.

Thomas Nast had become a political power. Every presidential candidate whom he supported was elected. Even General Grant, upon assuming the Presidency, attributed his election to the "sword of Sheridan and the pencil of Thomas Nast."

To Nast, all things were either right or wrong. There was nothing in between. He was absolutely merciless in his attacks upon those with whom he disagreed. The Ku Klux Klan, anarchists, Communists and corrupt politicians were among those upon whom he vented his wrath, while he vigorously supported, among other causes, sound money, a strong national·defense, the enfranchisement of blacks, the recognition of the rights of minority groups including American Indians, and Chinese, and the conservation of wildlife. Thomas Nast was a crusader, with a drawing pen instead of a lance, who was endowed with an uncanny foresight. Many of his cartoons are as appropriate today as when he drew them almost a century ago.

In 1879, changes in management at *Harper's* had resulted in less freedom for Nast to express his own views. A new generation of publishers did not wholly agree with what they considered the artist's tendency to advocate startling and, in their opinion, sometimes radical reforms. But Nast was uncompromising when it came to presenting views other than his own. "Policy," he said, "strangles individuals." Then too, with the introduction of new techniques in reproduction, the hand-engraved woodblock, which Nast used to such advantage, had become outmoded and the new methods were less suited to his style. Consequently, as Nast's drawings appeared less frequently in *Harper's Weekly* (they ceased entirely with the Christmas drawing of 1886) he took advantage of the opportunity to travel and invest his savings. He was at the same time much in demand as a lecturer, an activity that he abhorred. While Thomas Nast would have been the last to realize it, he had, at the age of thirty-nine, reached his peak. He had just about everything that he could wish for, a nationwide reputation for integrity gained by supporting the causes in which he believed, a beautiful home, a devoted wife and family and financial independence.

But, unfortunately, Nast's genius did not extend itself to the field of finance. The money he had earned during his years of fame was invested unwisely. An unprofitable mining venture in the West was followed in 1884 by the loss of most of his remaining savings in the failure of Grant and Ward, an investment house established by General Grant following his retirement from the Presidency. Hearing of Nast's adversity, Grant, anxious to do something for his old friend and supporter, had offered him an opportunity to invest in what appeared to be a very successful enterprise. But the firm failed soon after and Grant and Nast, victims of an unscrupulous partner, lost all that they had invested. Subsequently the failure of his effort to establish his own paper left the artist in straitened circumstances from which he never managed to extricate himself.

It was like manna from heaven, therefore, when in 1889 Nast's old friends at *Harper's* proposed that he get together a collection of his Christmas drawings for publication in book form by Harper & Brothers, a very Christmas-like gesture and one which the artist gratefully accepted.

Thomas Nast's book, *Christmas Drawings for the Human Race,* which forms the basis of this present volume, was published in time for the 1890 Christmas season. It contained pictures that had appeared in Christmas issues of *Harper's* over a period of thirty years as well as some drawn especially for inclusion in the book. The five Nast children were used frequently as models in many of the drawings and many scenes from the Nast home were incorporated also.

It seemed fitting that the artist's last assignment for the firm of Harper & Brothers should be on a theme transcending the fortunes of politics, thus offering him an opportunity to devote his talent to a subject very close to his heart but which had been subordinated to his political activities. The title was especially significant in that the cartoonist, who had formerly lampooned his adversaries with such vehemence, was now including all human beings in his offering of Christmas goodwill, regardless of race, creed or political affiliation.

Prior to Thomas Nast's portrayal of Santa Claus as the jolly, round-bellied, white-bearded, fur-clad embodiment of good cheer, as described in Clement Moore's "Night before Christmas" poem, St. Nicholas had been pictured as everything from a stern patriarch in bishop's robes to the gnome-like figure in frock coat and pantaloons who appeared in the first edition of Moore's poem.

It remained for Thomas Nast to capture the spirit of those rollicking lines " 'Twas the night before Christmas when all through the house/Not a creature was stirring, not even a mouse" and bring to life the scenes that are so much a part of our Christmas heritage—the reindeer-drawn sleigh on the snow-capped roof, the stockings hung by the chimney and the emergence from the fireplace of the gift-laden Santa.

Santa's workshop at the North Pole was also a product of Nast's imagination (p. 3). Just why Santa chose the North Pole as his base of operations has never been quite clear but the chances are that logistics had something to do with it. The North Pole was equidistant from most of the countries that Santa visited in the Northern Hemisphere. And it may be assumed that he

wished to locate someplace where he would not be spied upon by inquisitive youngsters. Then too, the reindeer and sleigh described by Clement Moore suggested a snowy environment. Furthermore, as a resident of the North Pole, no country could claim him as a national. (It should be noted, however, that Nast did not hesitate to appropriate Santa for the Union cause in "Santa Claus in Camp," p. 54, by clothing him in a star-spangled jacket and trousers striped like a flag.)

The Christmas drawings offer a profusion of the symbols and events linked with the modern conception of Christmas, especially a child's Christmas. There is an abundance of the toys so popular with the children of that day, some of which present-day oldsters will remember with nostalgia: jumping jacks and jacks-in-the-box, hobbyhorses, toy soldiers, wooden animals, miniature houses and trees to be laid out in little villages, dolls with china heads and sawdust-filled bodies, dolly dresses and furnished dollhouses, tenpins, drums, tools and building blocks—enough to keep Santa Claus busy all year long.

Holly and mistletoe are everywhere to be seen. In "A Christmas Flirtation" (p. 42) a young lady, modeled by the artist's daughter Julia, stands under a sprig of mistletoe well laden with berries. According to Washington Irving, young men in the England of his day plucked a berry everytime they kissed a girl. When the berries were all gone, the privilege ceased. And the holly that adorns Santa Claus' fur cap is reminiscent of Christ's crown of thorns.

The two drawings of the Christ Child or Christkindchen (pp. 64, 65) require some explanation. In Germany during the Reformation of the sixteenth century it was alleged that St. Nicholas was too closely associated with the Catholic Church, so he was banished and the Christkindchen (or Christkindl) took his place. The child is said to have been a girl who acted as a messenger to distribute presents from the infant Jesus. Although the custom never gained wide observance in the United States, Nast recalled it as a part of his German heritage. It seems odd that the one German custom that has always been popular in America, the Christmas tree, is not much to be seen in the drawings.

One might wonder how Mother Goose managed to find her way into a book about Christmas (p. 9). Probably for no other reason than that Mother Goose and Santa Claus were part of the same world of make-believe and that Mother Goose, like Santa, was loved by little children. Furthermore, a more compatible couple could scarcely be imagined. (The fireplace with Mother Goose nursery rhymes pictured in the book actually existed in the Nast home in Morristown, New Jersey.)

Thomas Nast's *Christmas Drawings* portray all of these traditions, customs and tales and vividly recall those precious moments when children rushed in to see the presents that had been left under the tree. In all of the drawings showing little children, one senses Nast's love of home and the excitement that pervaded the air on Christmas Eve.

Following the publication of his *Christmas Drawings* in 1890, Thomas Nast spent a great deal of his time in his studio at home painting in oils. Most of his pictures had to do with Civil War subjects, many of them based on sketches he had made as a Civil War correspondent years earlier. Had he followed his early aspiration to become a painter, Thomas Nast might well have gained eminence in that field rather than as a cartoonist. Critics have acknowledged that his paintings, while they appear labored, have a heavy power and deserve more recognition than they have received. Several of his paintings were exhibited, and some still hang, in important libraries and art galleries around the country. Old friends commissioned much of this work and while payments were liberal, income from this source was insufficient to support his family.

What bothered the artist most as the century came to a close was that he was still heavily in debt and could no longer be as generous to his family and friends as he had been during his more affluent years.

In 1901, Theodore Roosevelt succeeded to the Presidency of the United States. Roosevelt had long admired Nast for the fighting spirit they both shared and, wishing to help him in his adversity, offered him an appointment as Consul General in Ecuador. It was not an assignment that appealed to the artist, but, desperately in need of funds, he accepted. He sailed alone from New York in July 1902, leaving behind a family and home that he would never see again. Guayaquil, the principal port of Ecuador where the Consulate was located, had recently been ravaged by fire. Nast was sixty years old at the time and the climate would have been difficult for a much younger man to endure. In addition, sanitary conditions were poor and yellow fever was prevalent. On December 1 he contracted the fever. On December 7 he died, but not before he had sent home enough money to pay off his debts.

Over half a century after his death Thomas Nast's home, Villa Fontana in Morristown, was designated a National Historic Landmark and the Thomas Nast

Christmas Village on the Morristown Green is now the center of attraction during the holiday season. Here children delight in viewing the life-size reproductions and animated replicas of the artist's Christmas drawings that are part of a permanent exhibit.

In 1956 the U.S. State Department placed a memorial plaque on the barracks where Thomas Nast was born as a "gift to the German people in friendship and in memory of Thomas Nast." And to further demonstrate that the city of his birth has not forgotten him, Landau/Pfalz, as it is now called, in December 1977 held a two-day festival in his memory. On the 7th, German and American dignitaries joined to honor him on the seventy-fifth anniversary of his death. Bands played, speeches were made and wreaths were laid. And, not unmindful of the importance of Santa Claus in the life of Thomas Nast, Santa shared the honors with him on St. Nicholas Day, December 6.

Nast's legacy was immense. It is to him that we owe the Republican Elephant and the Democratic Donkey as well as our conceptions of Uncle Sam, John Bull, Columbia and, perhaps most important, Santa Claus. It is not unlikely that the image by which Thomas Nast would most like to be remembered is his jolly old Santa.

Thomas Nast loved Christmas and entered into its spirit with childlike delight. And may his Christmas Drawings serve to remind us that it is still true, as it was in 1843 when Charles Dickens wrote his immortal *Christmas Carol*, that "it is good to be children sometimes and never better than at Christmas when its mighty Founder was a child himself."

THOMAS NAST ST. HILL

THOMAS NAST'S
CHRISTMAS DRAWINGS

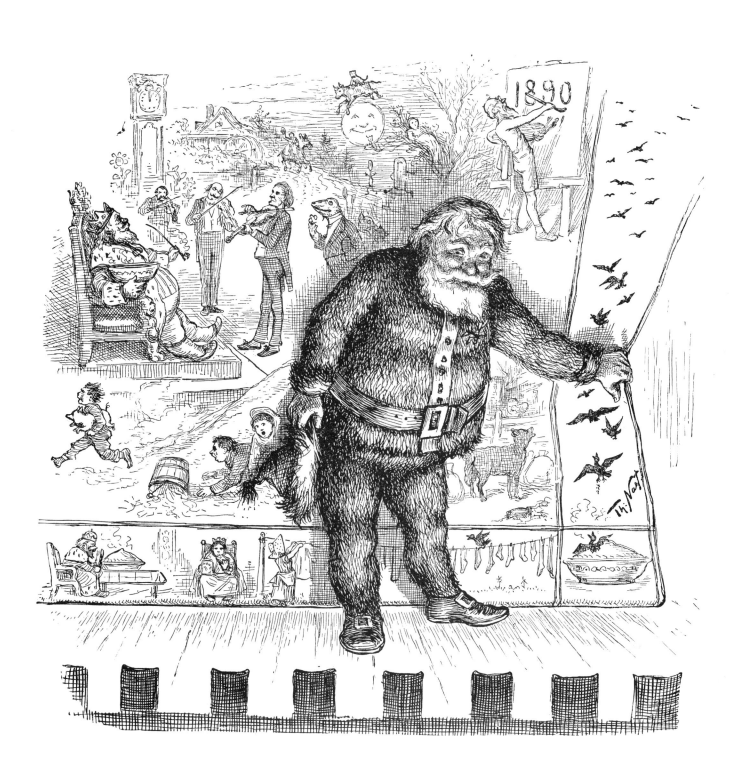

RINGING IN THE AIR.

DING!

DONG!!

Santa Claus's Route

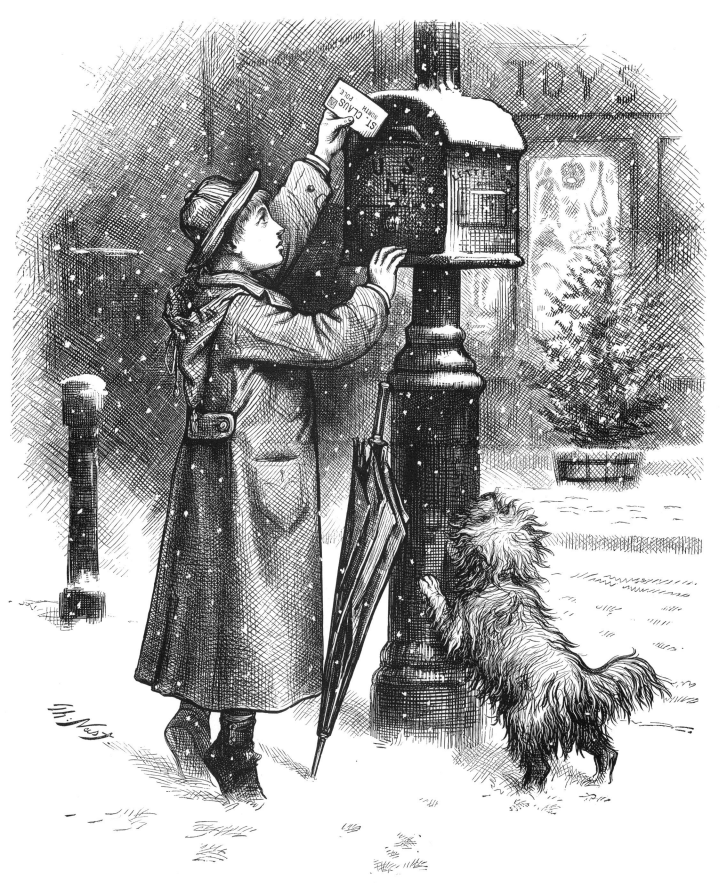

Christmas Post

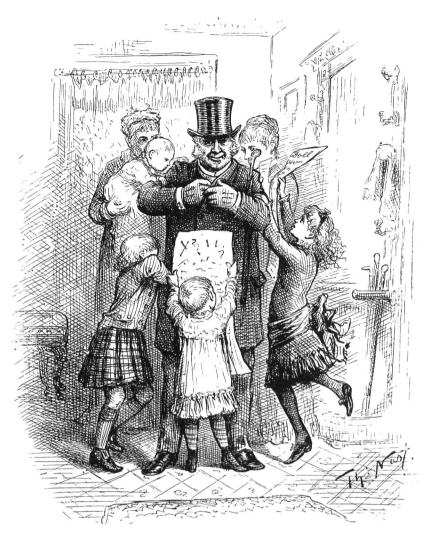

Messages and Lists for Santa Claus

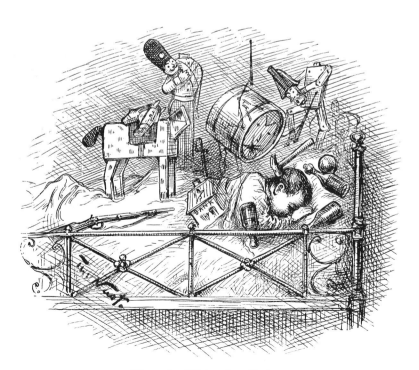

'Twas the Night after Christmas

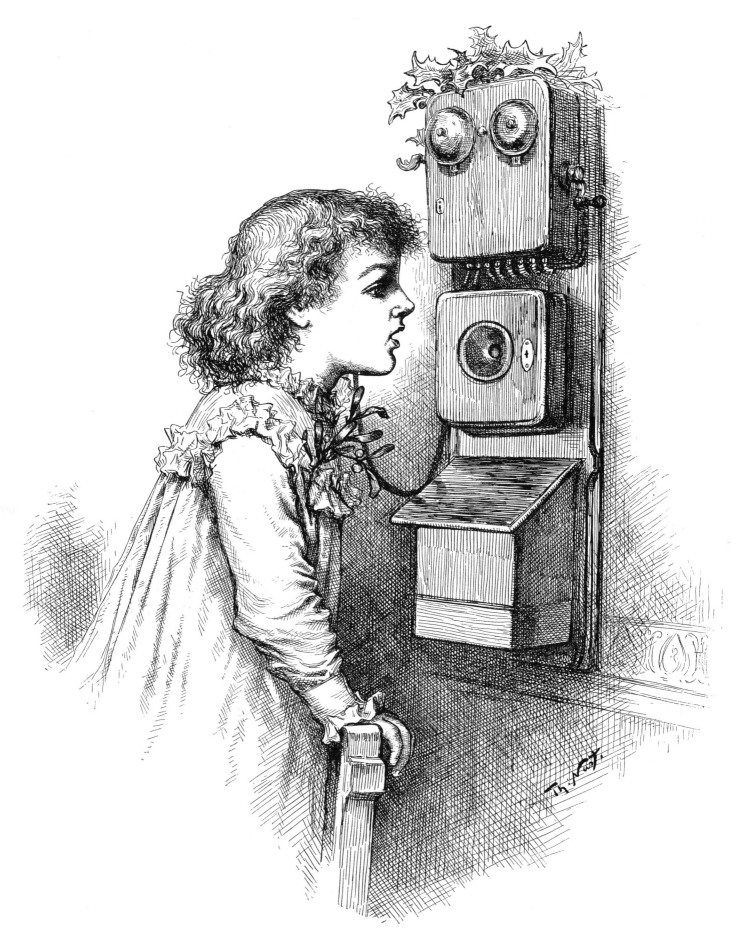

"Hello! Santa Claus!"

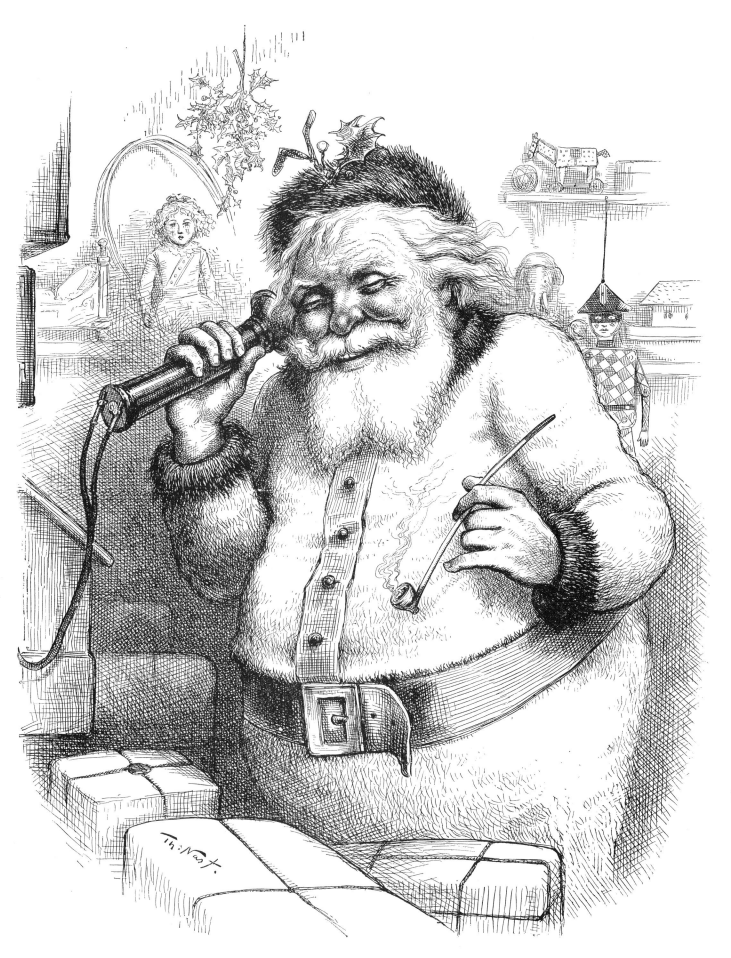

"Hello! Little One!"

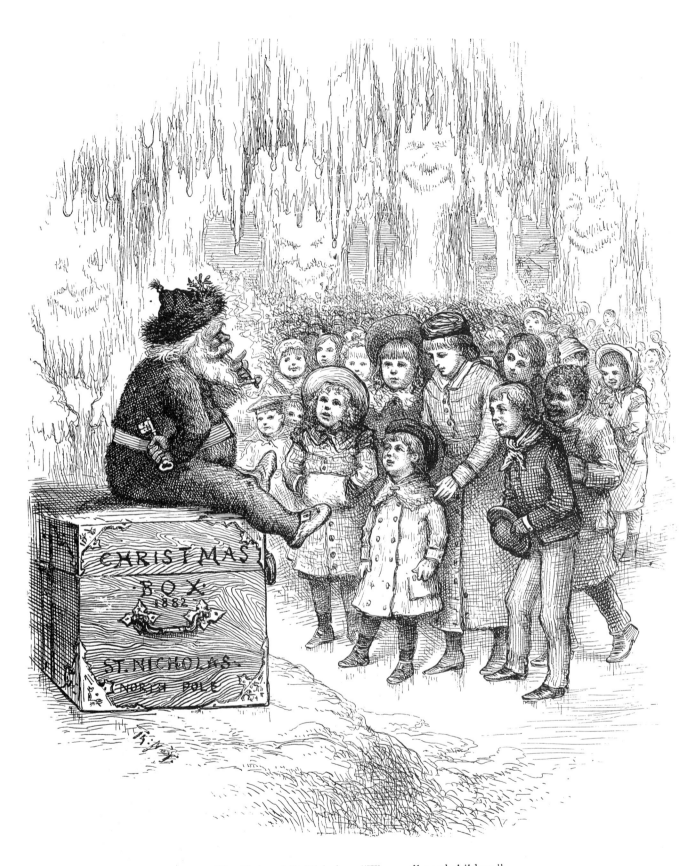

The Shrine of St. Nicholas—"We are all good children."

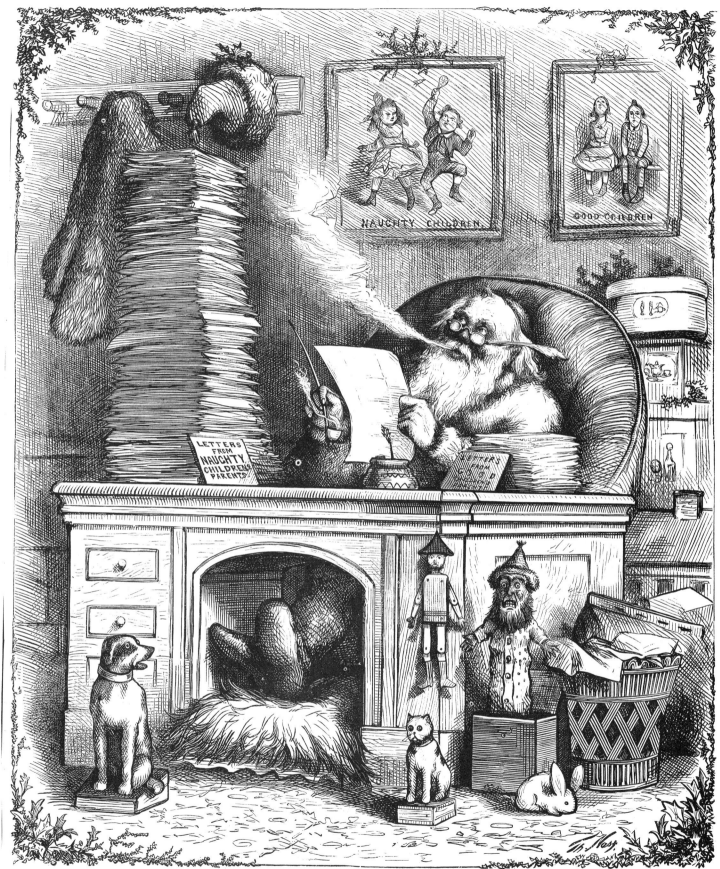

Santa Claus's Mail

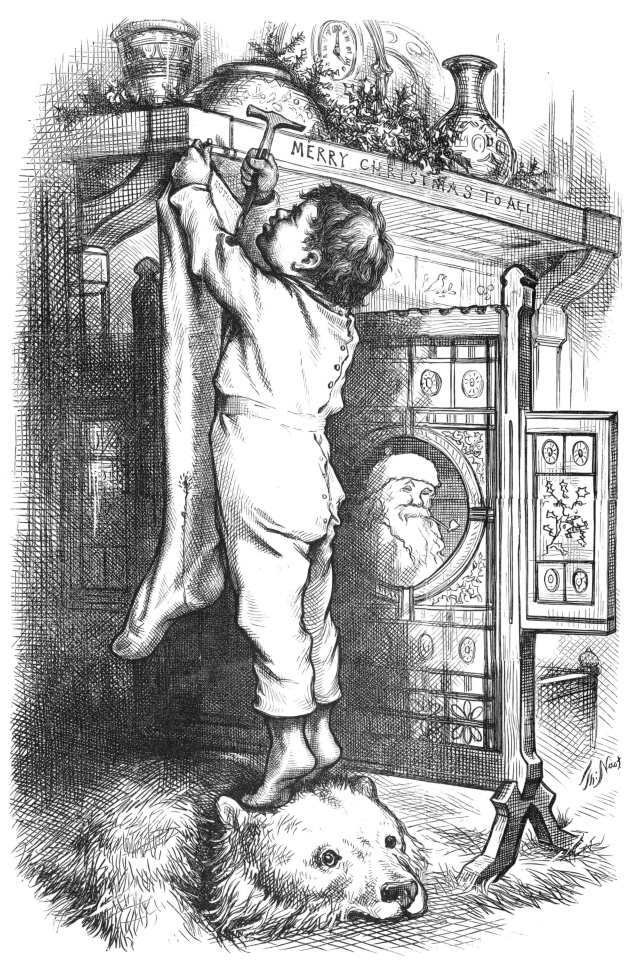

" 'Twas the Night before Christmas." A Chance to Test Santa Claus's Generosity.

13

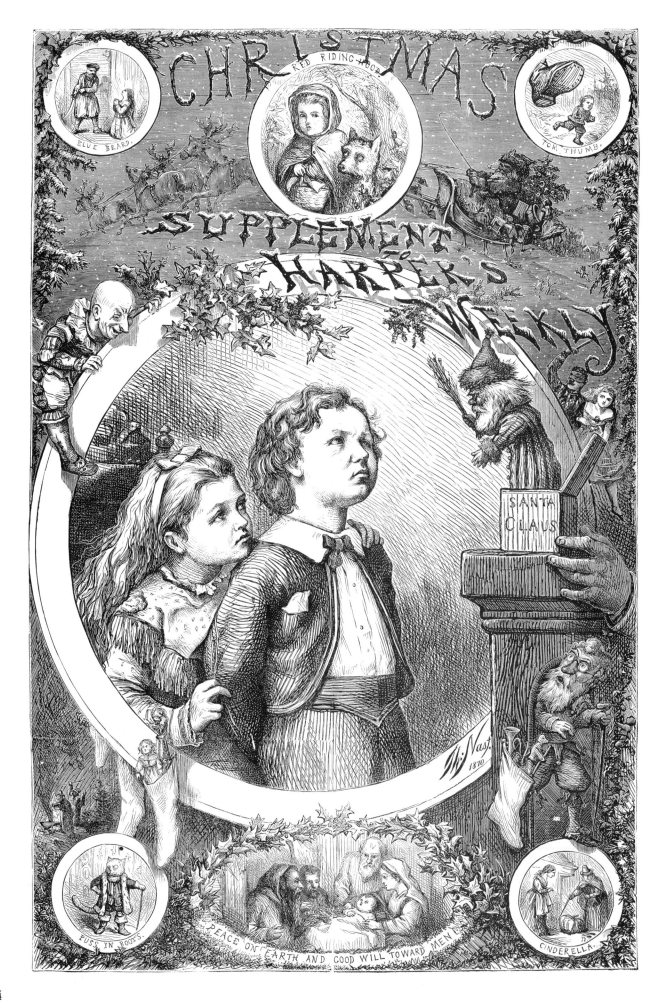

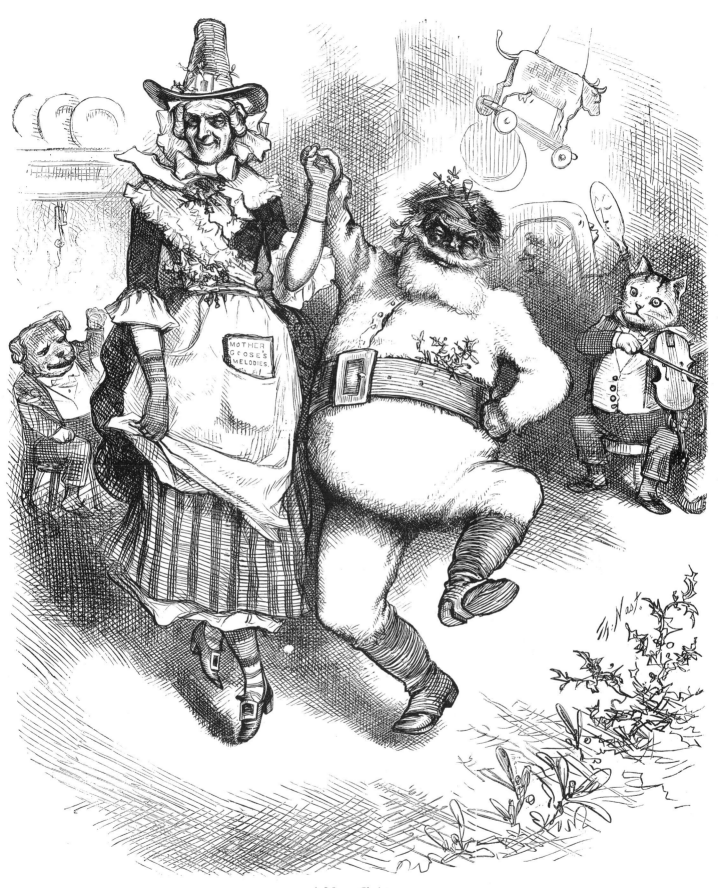

A Merry Christmas

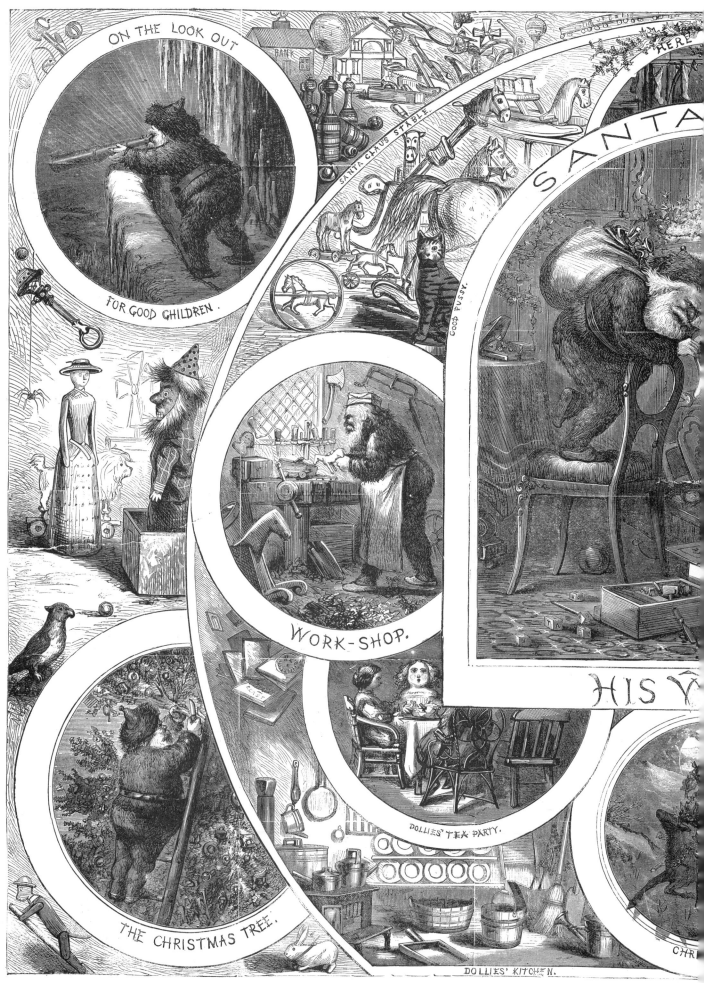

ON THE LOOK OUT

FOR GOOD CHILDREN.

SANTA CLAUS STABLE.

GOOD PUSSY.

WORK-SHOP.

THE CHRISTMAS TREE.

DOLLIES' TEA PARTY.

DOLLIES' KITCHEN.

SANTA

HERE

HIS Y

CHR

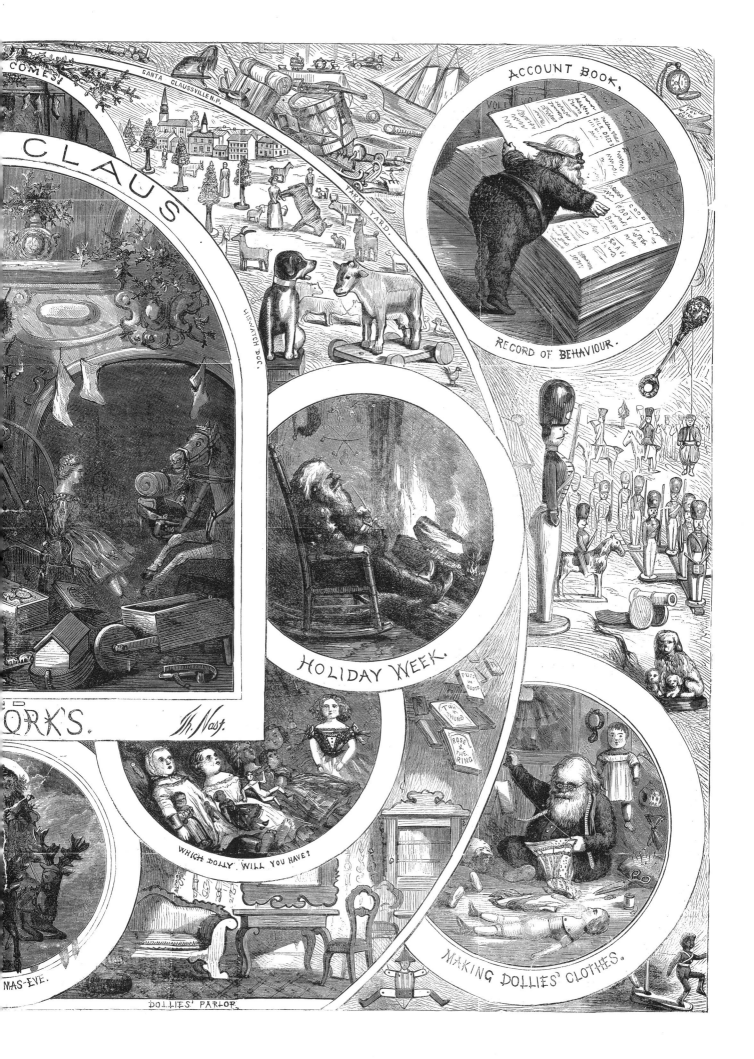

SANTA CLAUS COMES!

SANTA CLAUSSVILLE N.P.

FARM YARD.

IIS WATCH DOC.

ACCOUNT BOOK,

RECORD OF BEHAVIOUR.

HOLIDAY WEEK.

ÖRK'S.

Th. Nast.

WHICH DOLLY WILL YOU HAVE?

DOLLIES' PARLOR.

MAS-EVE.

MAKING DOLLIES' CLOTHES.

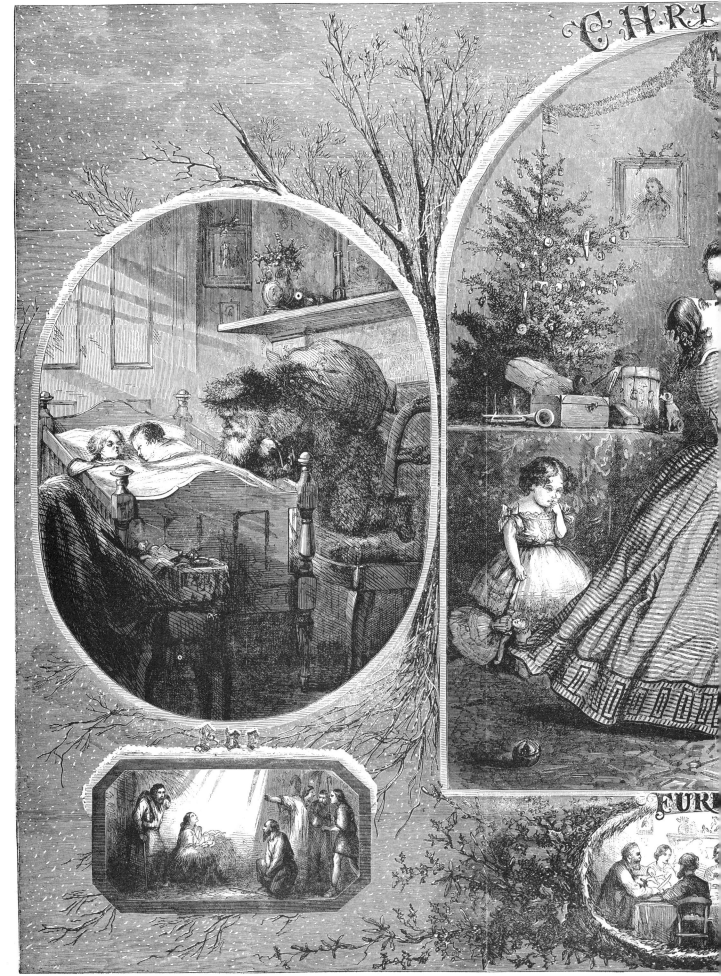

Christmas, 1863

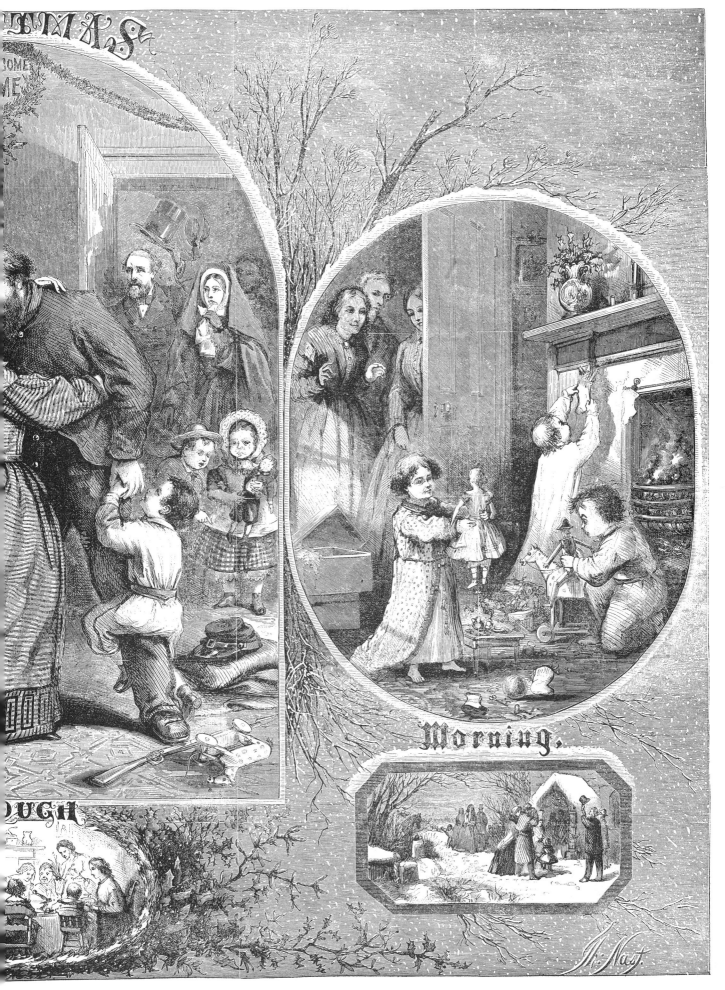

Morning.

Th. Nast.

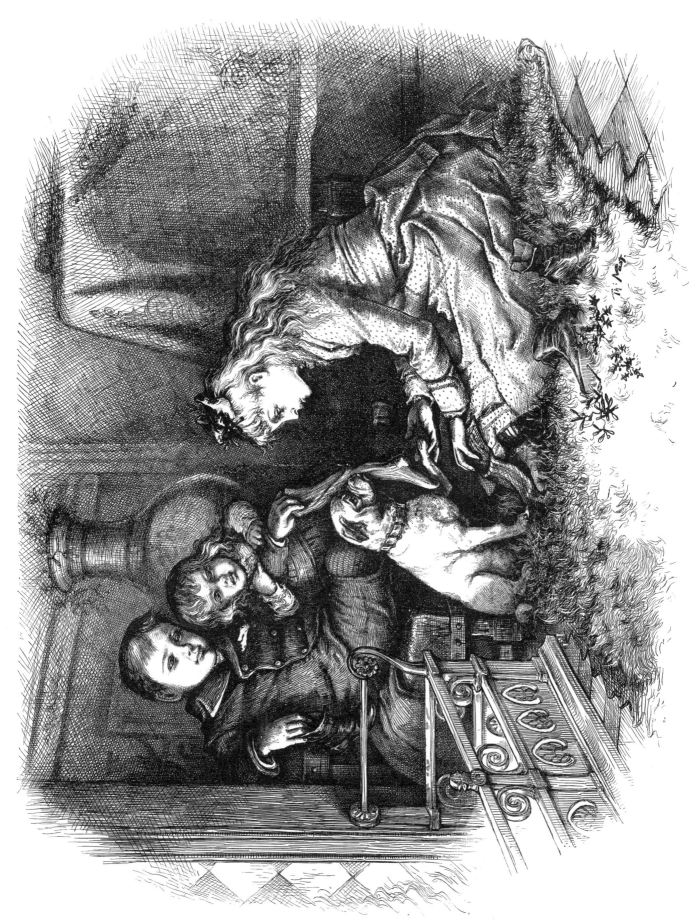

Christmas Fancies—"Don't you wish you wore stockings?"

"Santa Claus can't say that I've forgotten anything."

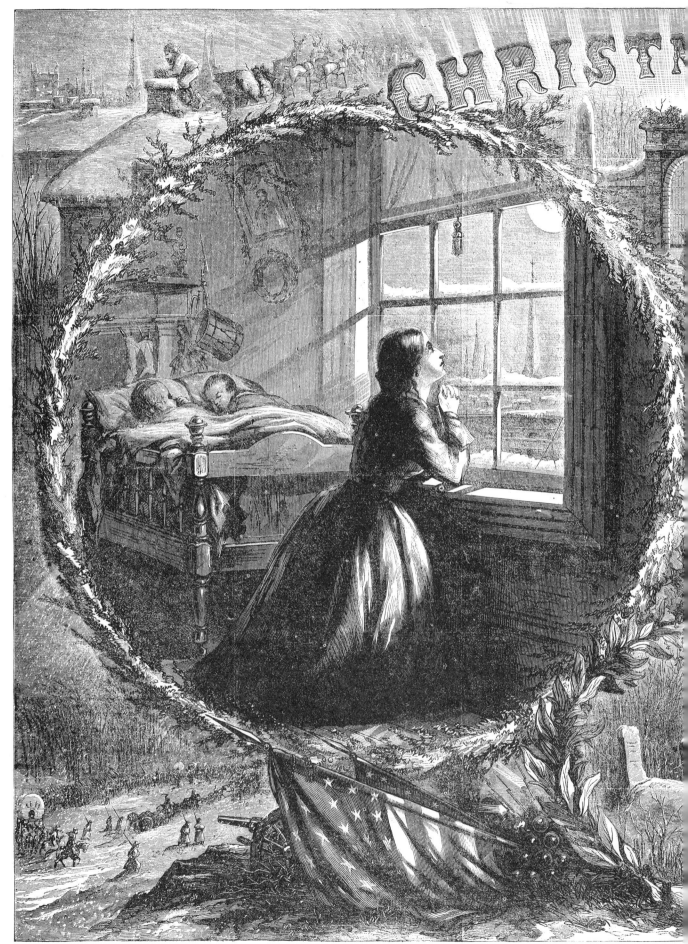

Christmas Eve, 1862

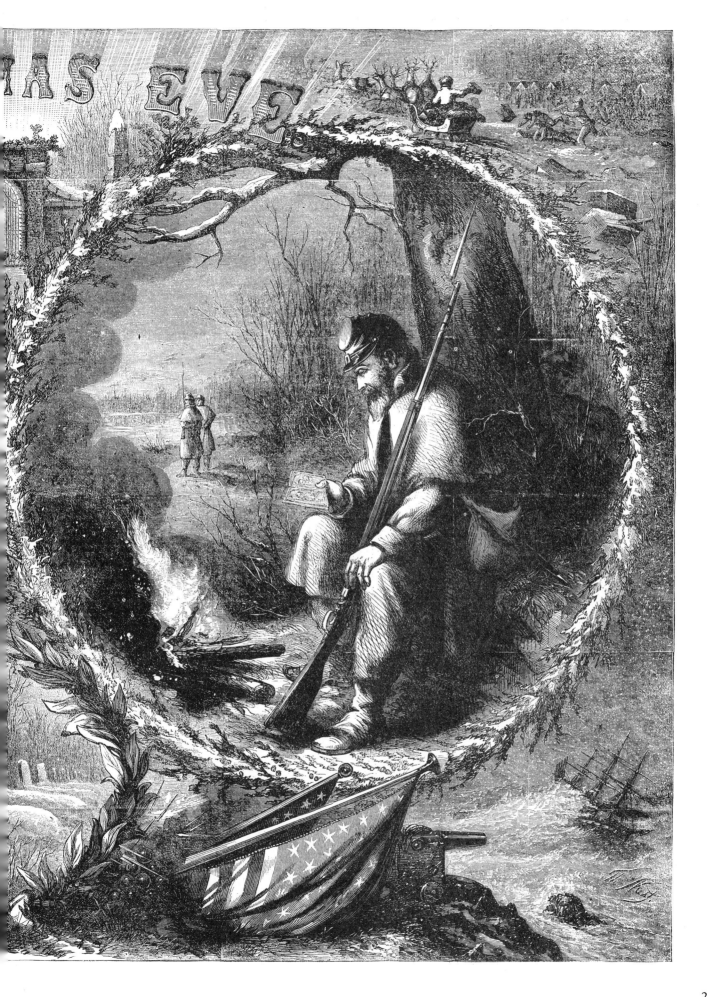

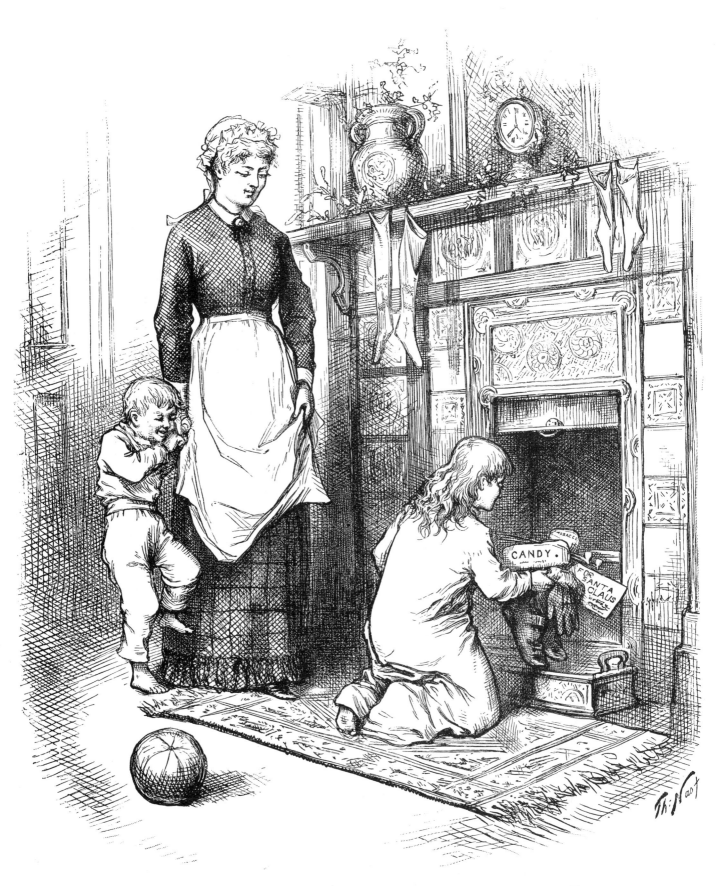

Reciprocation. "Won't Santa Claus be surprised to find that he had not been forgotten?"

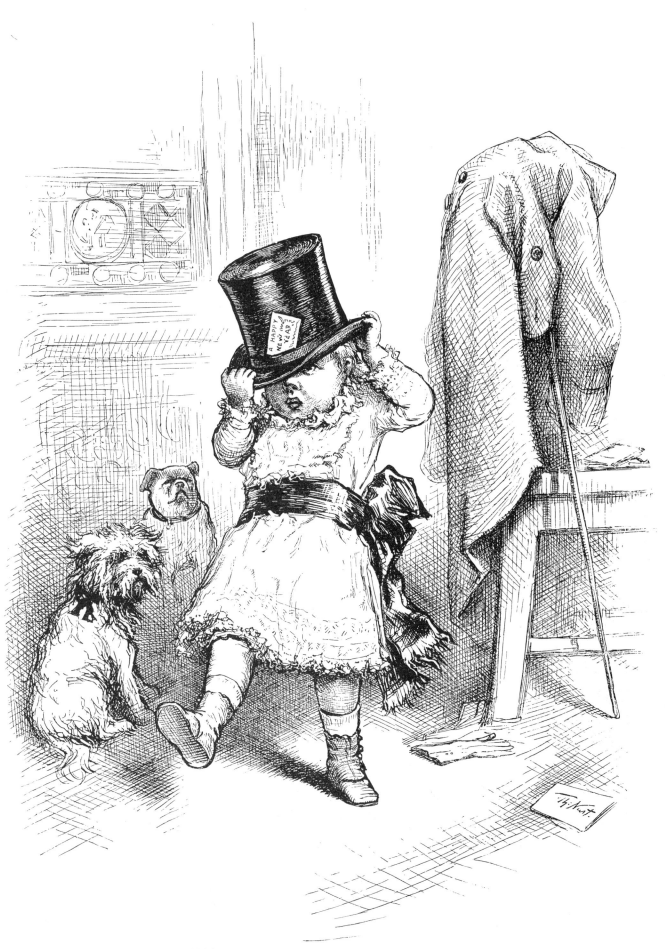

"Wishing you a Merry Christmas and a Happy New Year."

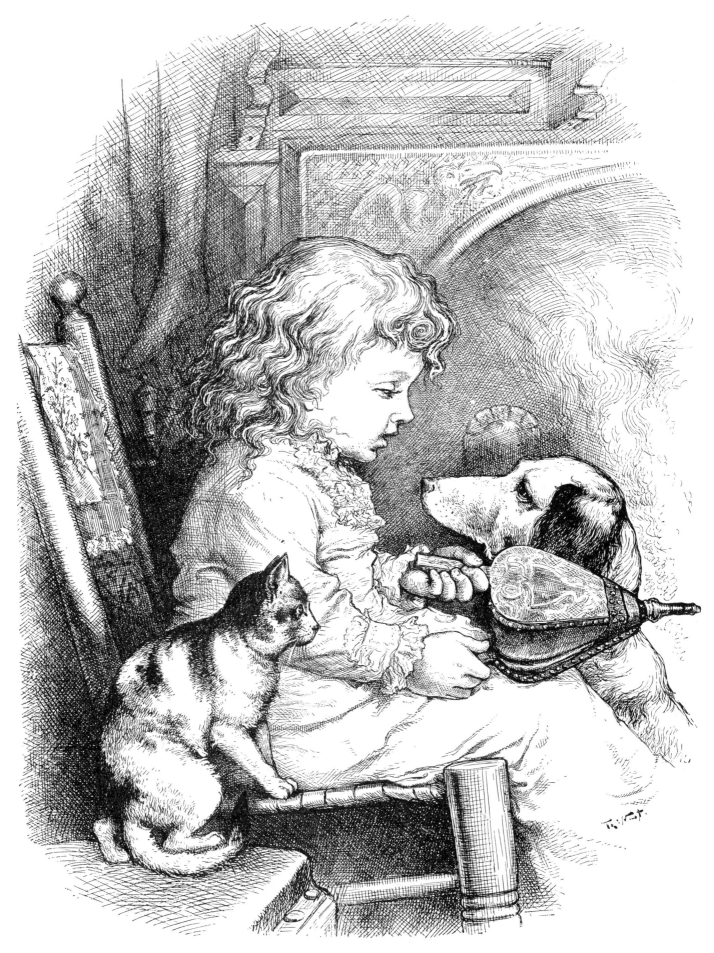

A Christmas Story. "I am Cinderella, and you are the wicked sisters."

28

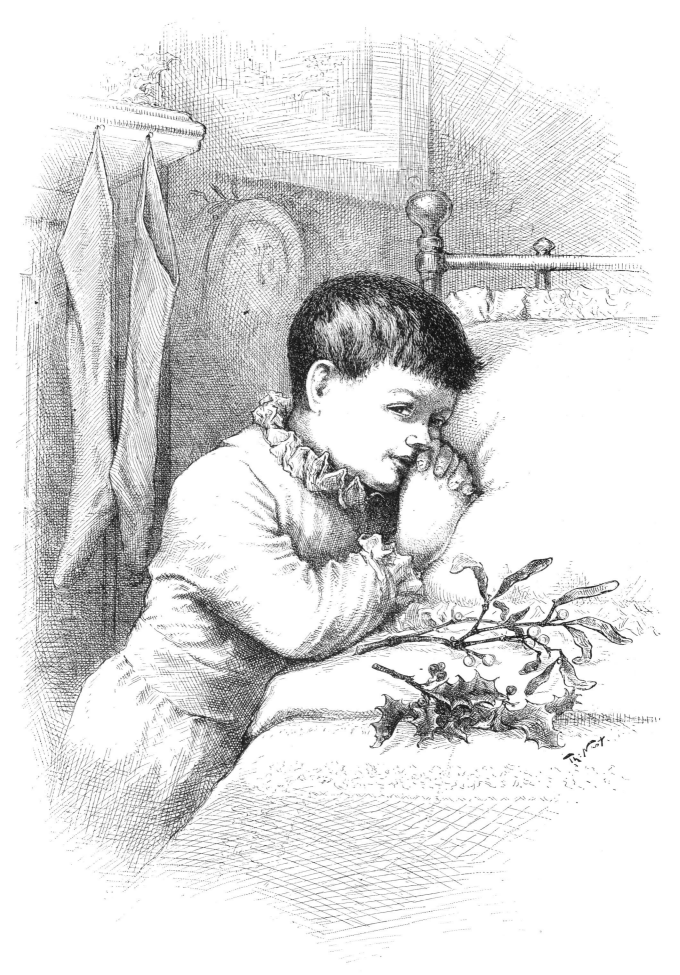

"He prayed, 'And let Santa Claus fill my stockings just as full as he can. Amen.'"

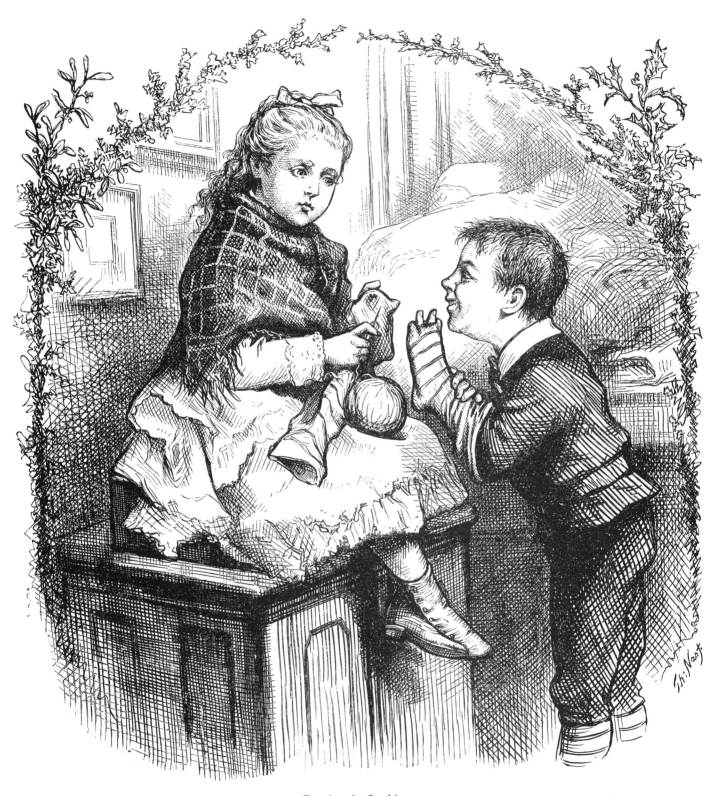

Darning the Stockings

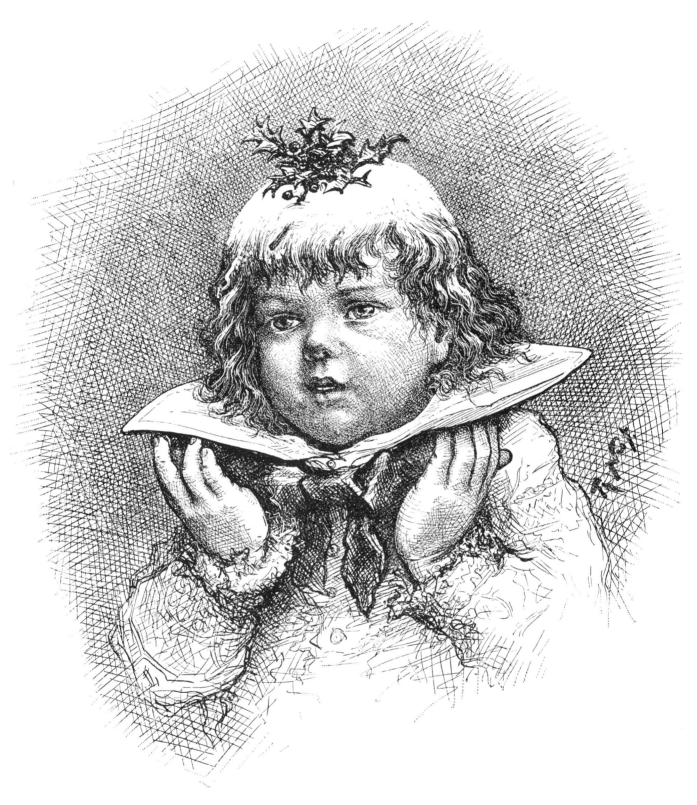

See! The Christmas Plum Pudding

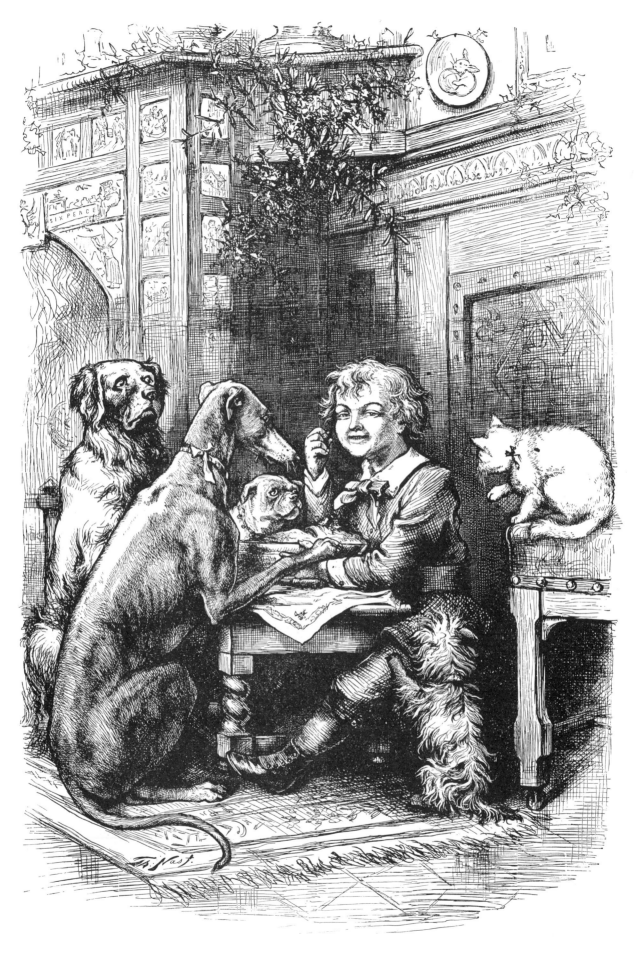

Little Jack Horner

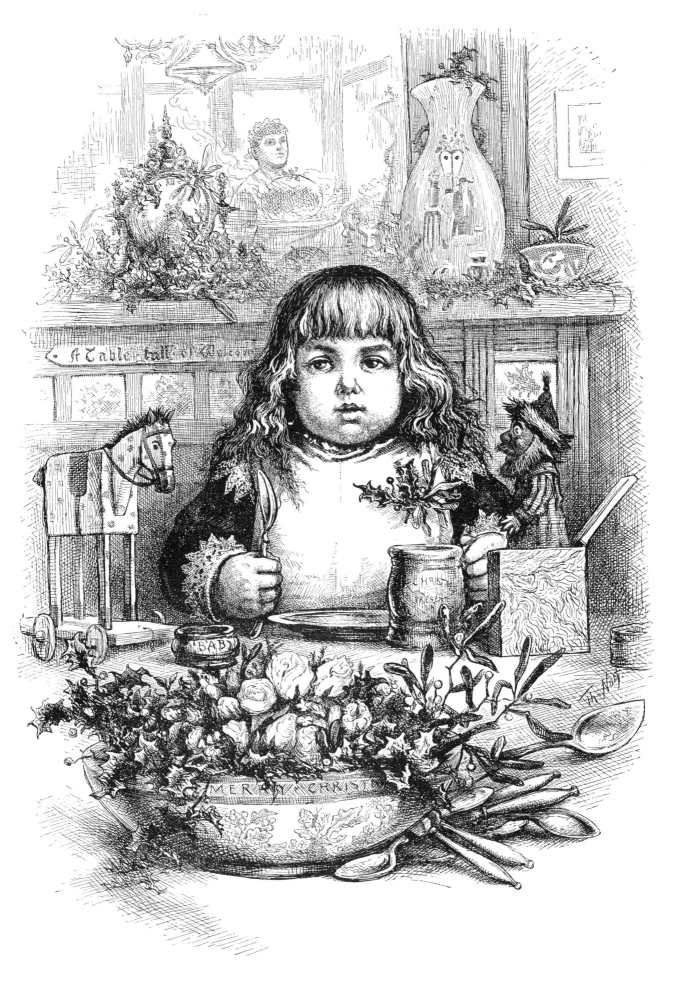

33

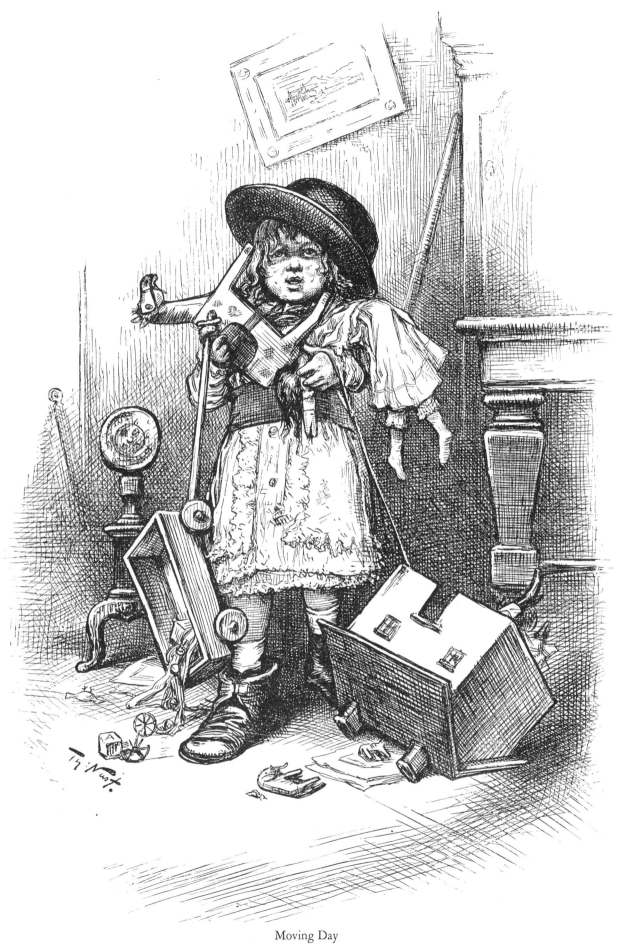

Moving Day

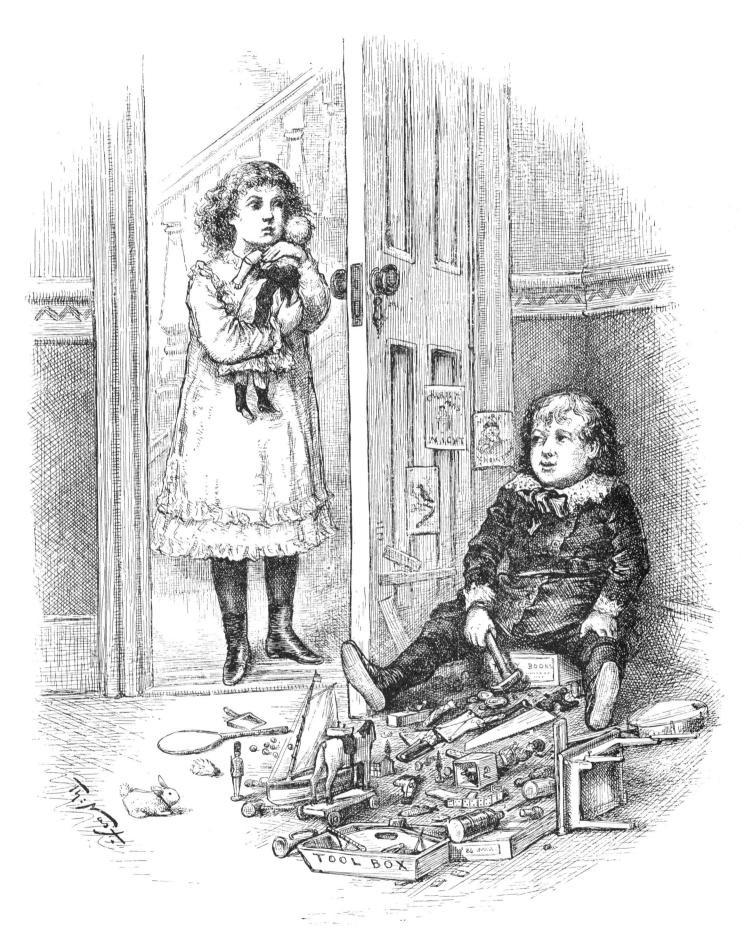

Santa Claus's Tool-box

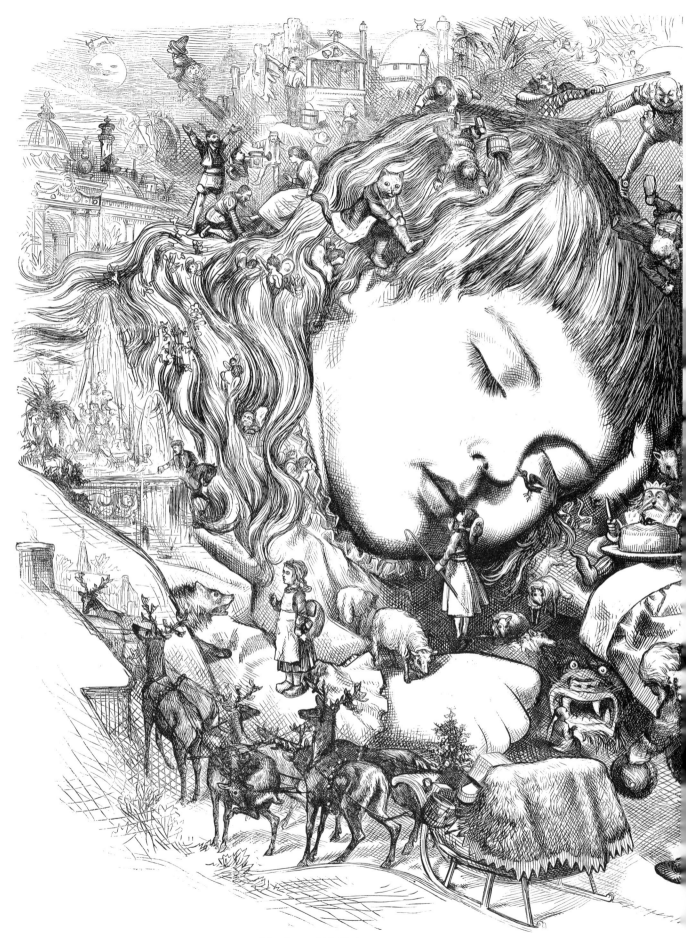

The Same Old Christmas Story Over Again

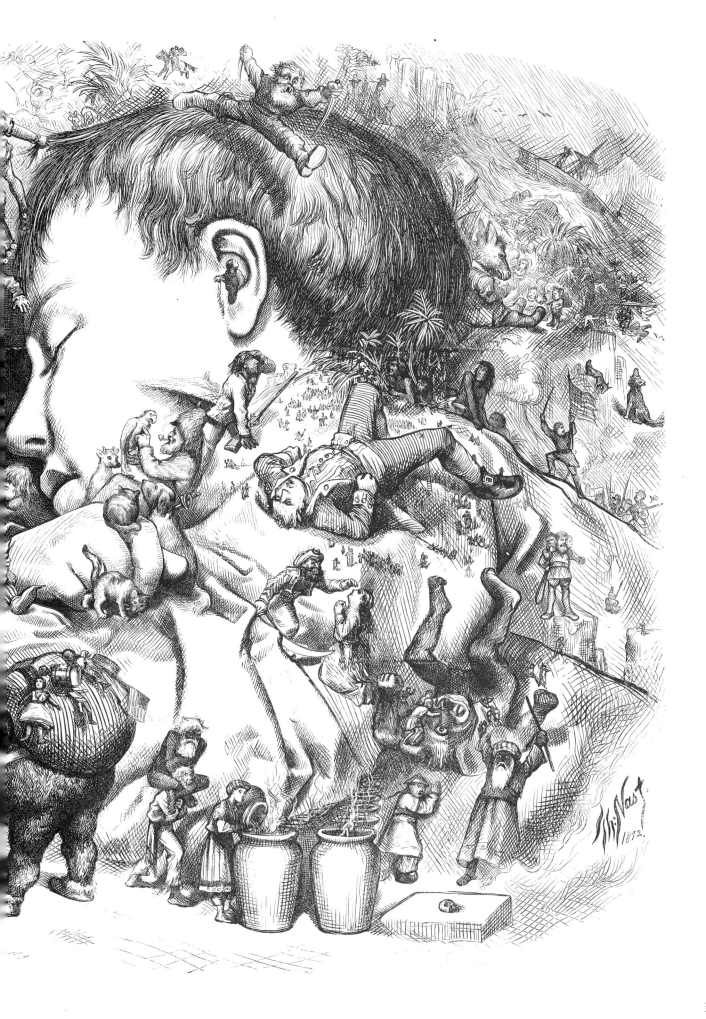

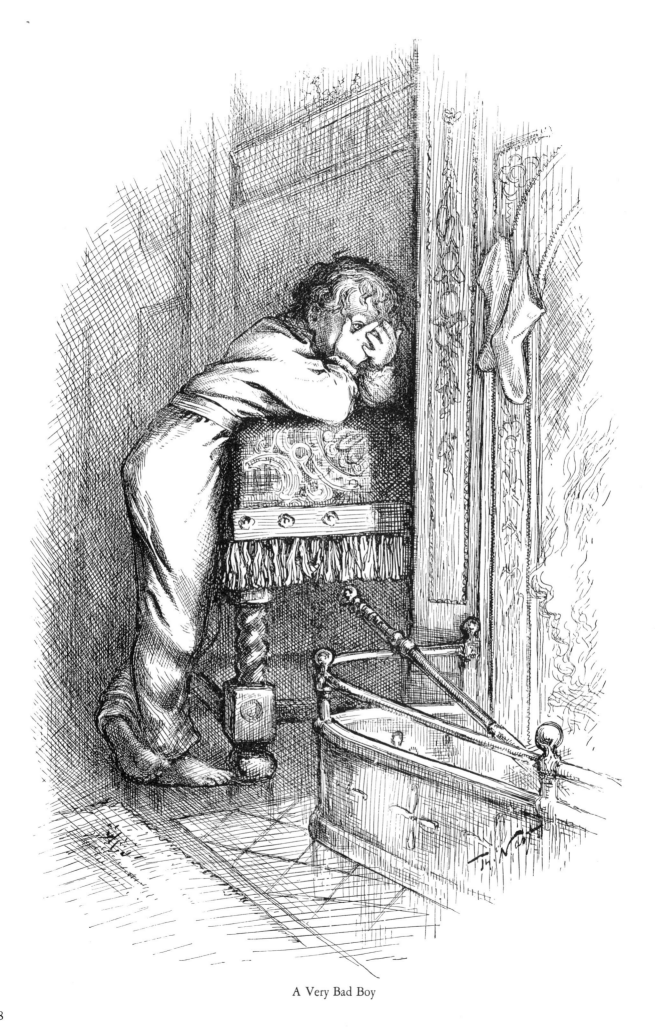

A Very Bad Boy

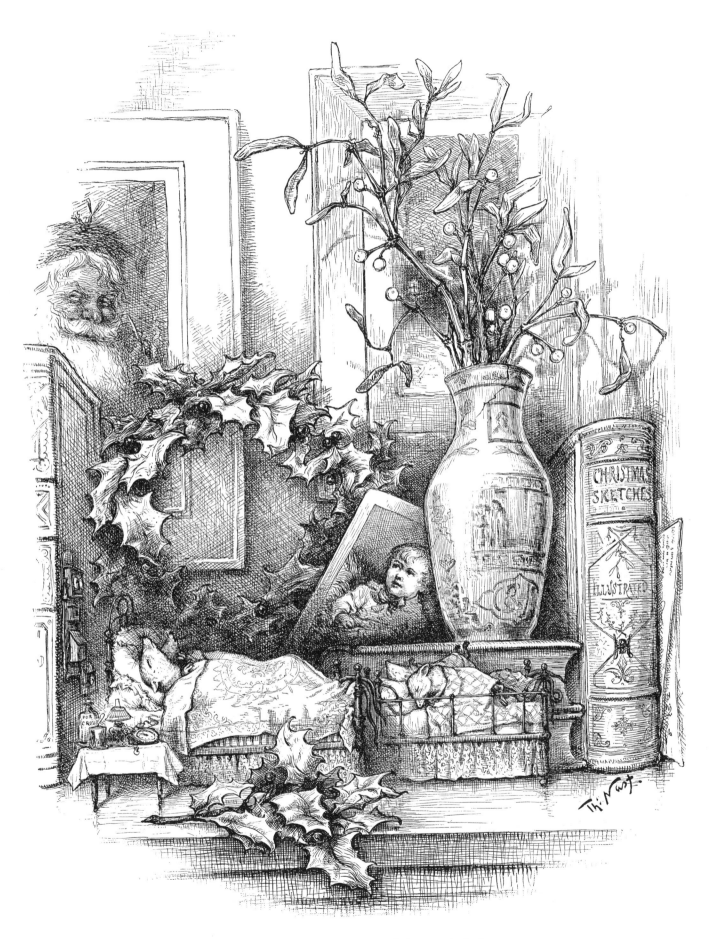

" 'Twas the night before Christmas, and all through the house
Not a creature was stirring, *not even a mouse.*"

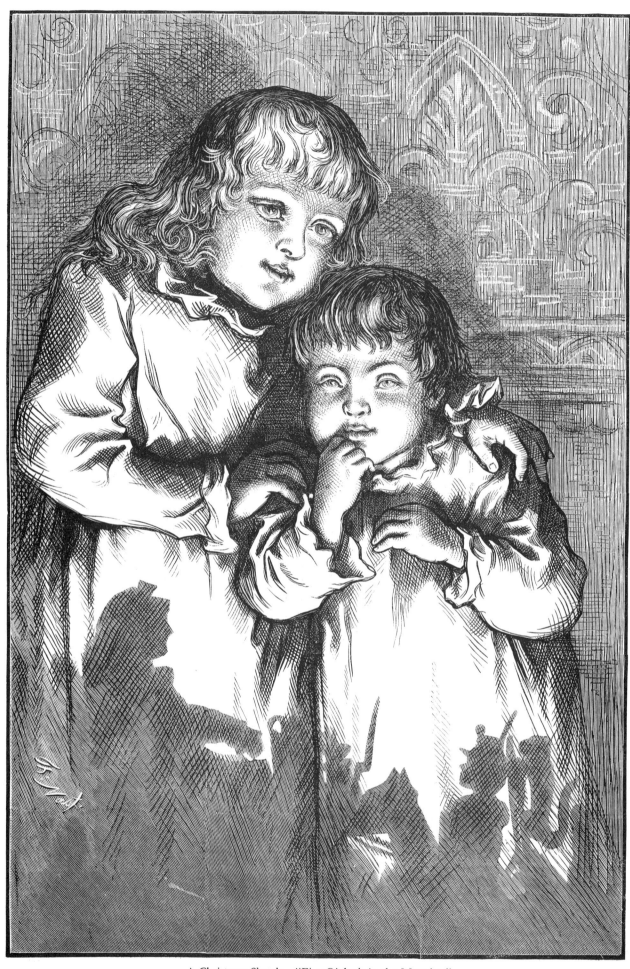

A Christmas Sketch—"Five O'clock in the Morning"

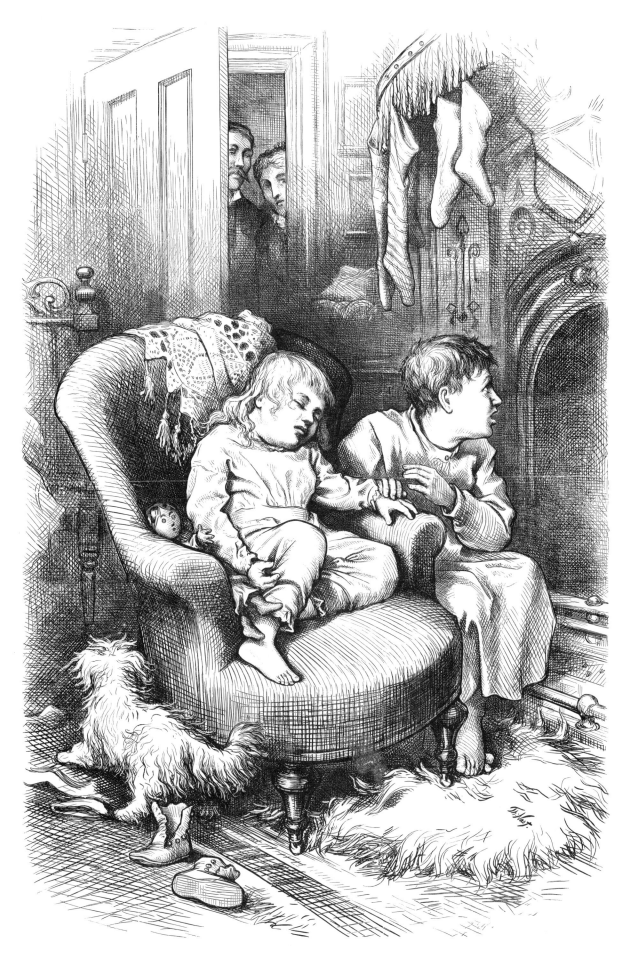

The Watch on Christmas Eve

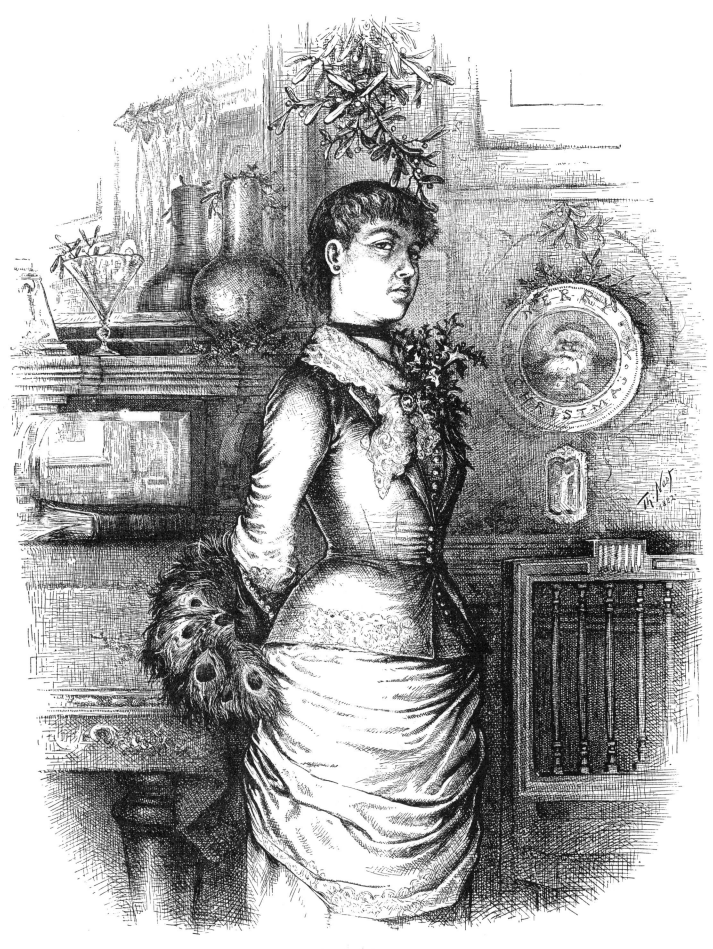

Christmas Flirtation

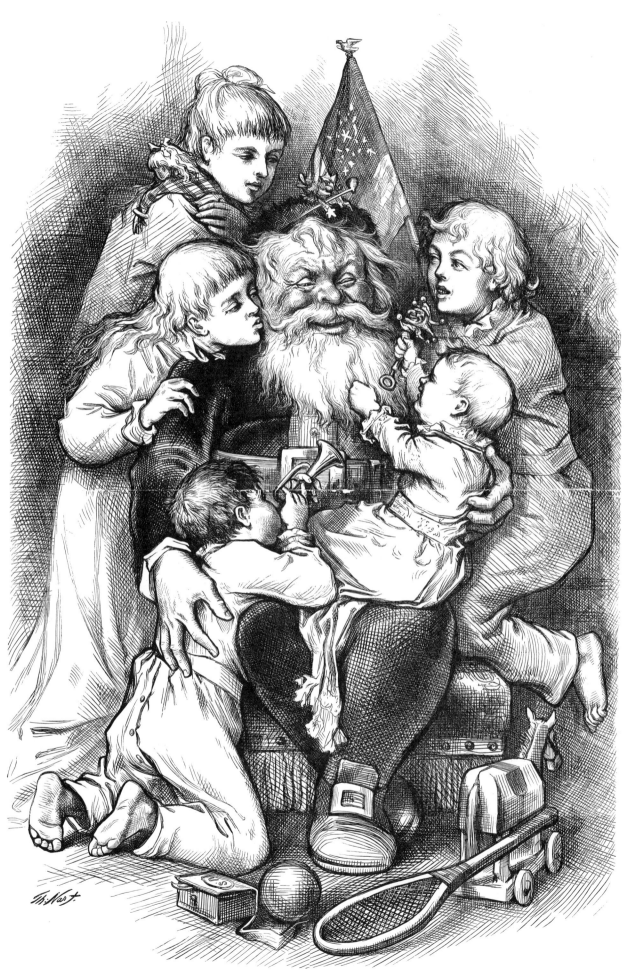

Merry Christmas

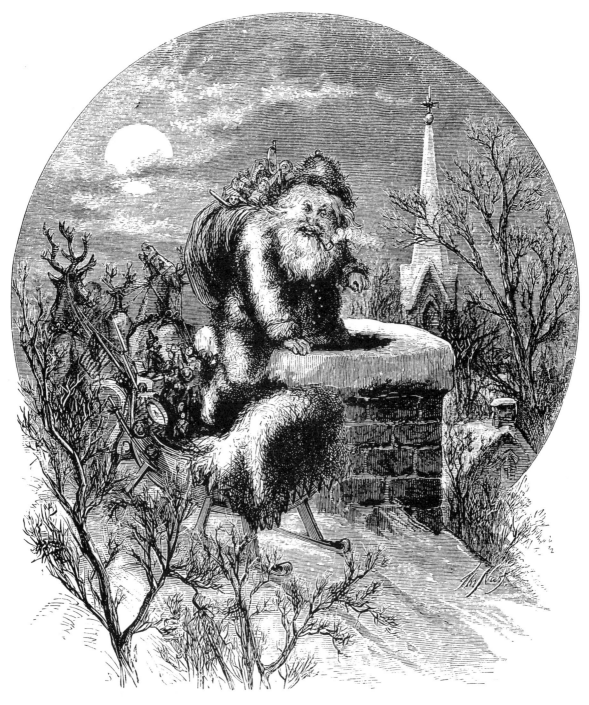

A Visit from St. Nicholas

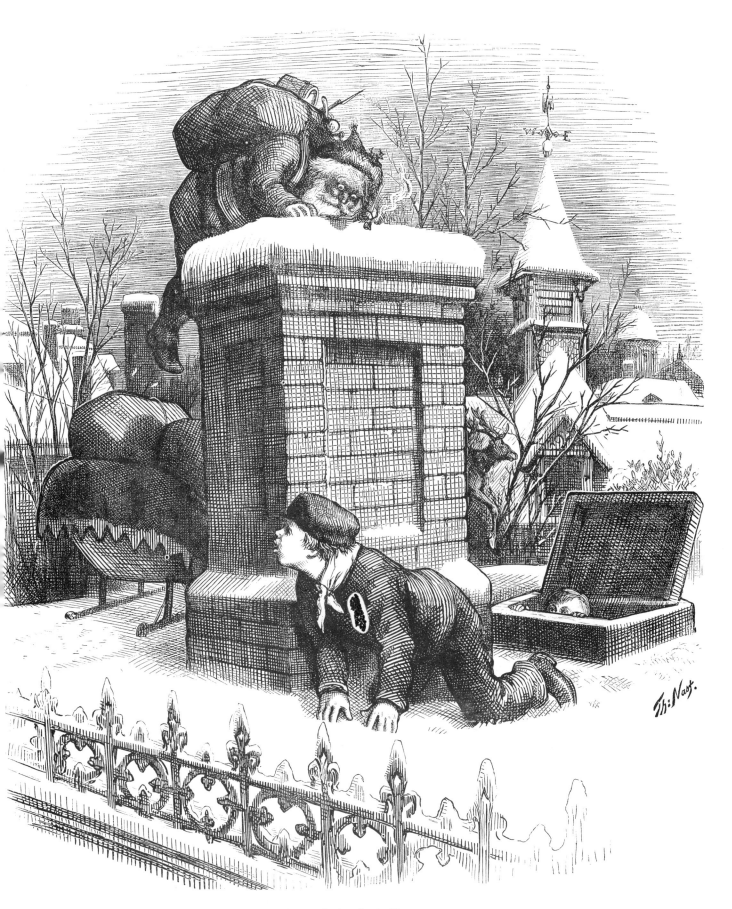

Seeing Santa Claus

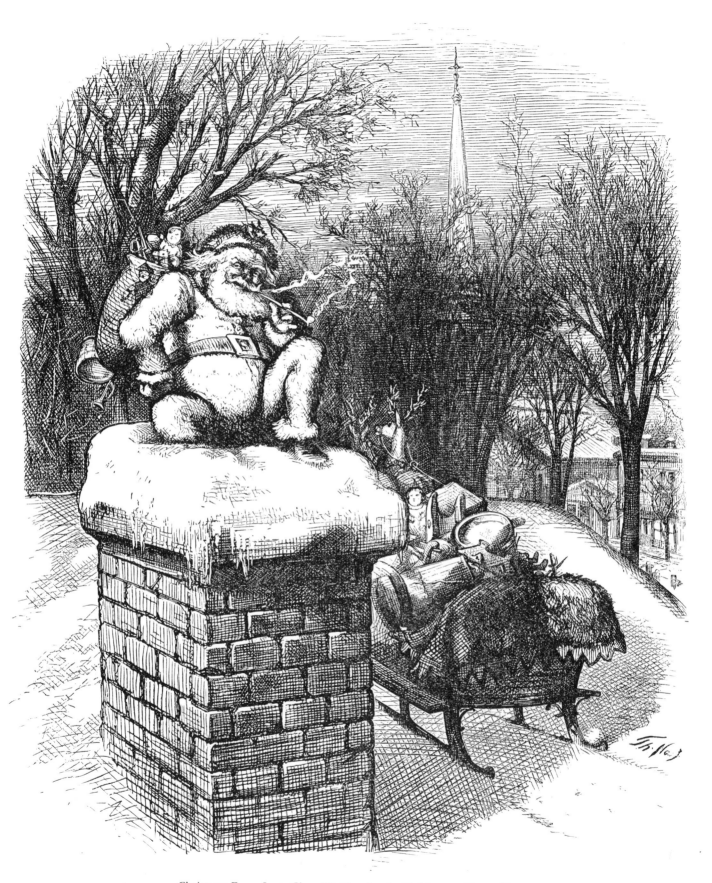

Christmas Eve—Santa Claus Waiting for the Children to Get to Sleep

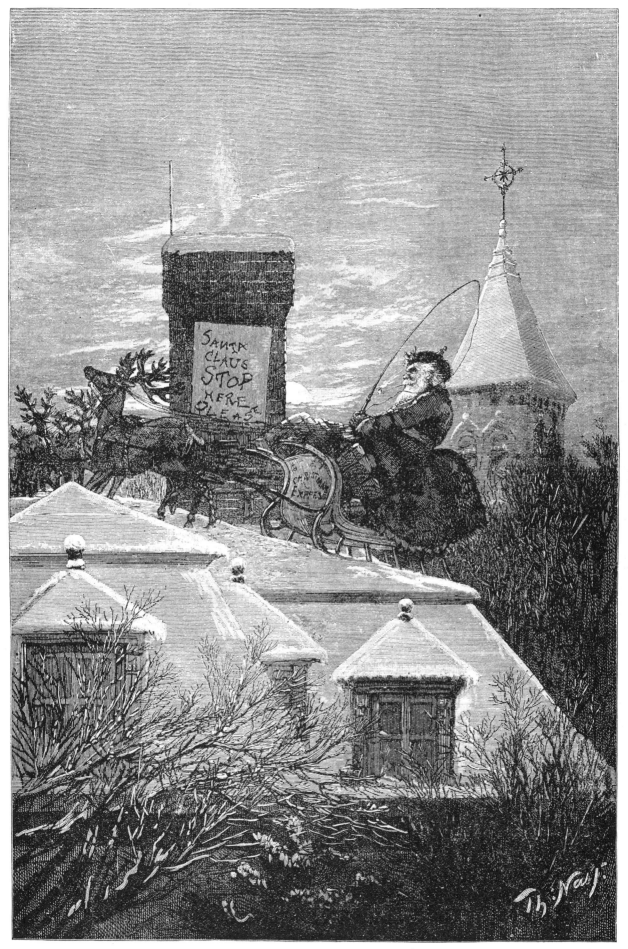

Christmas Station

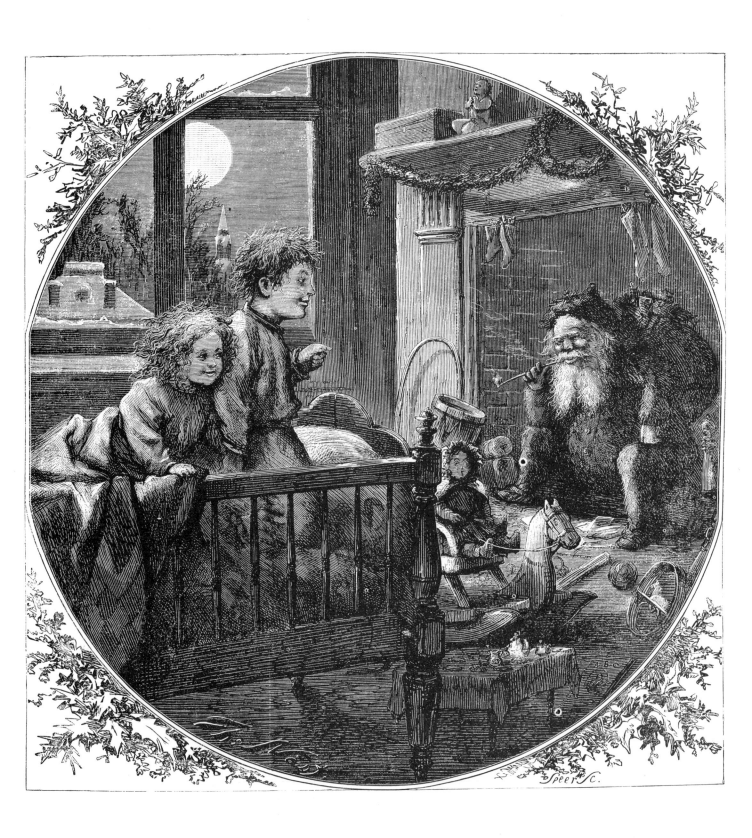

48

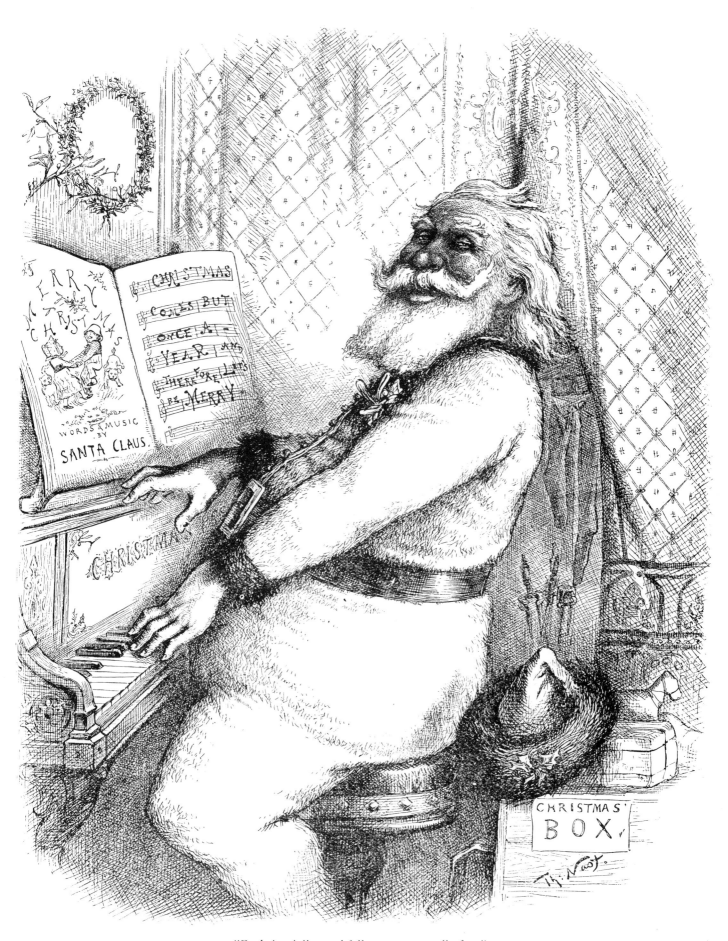

"For he's a jolly good fellow, so say we all of us."

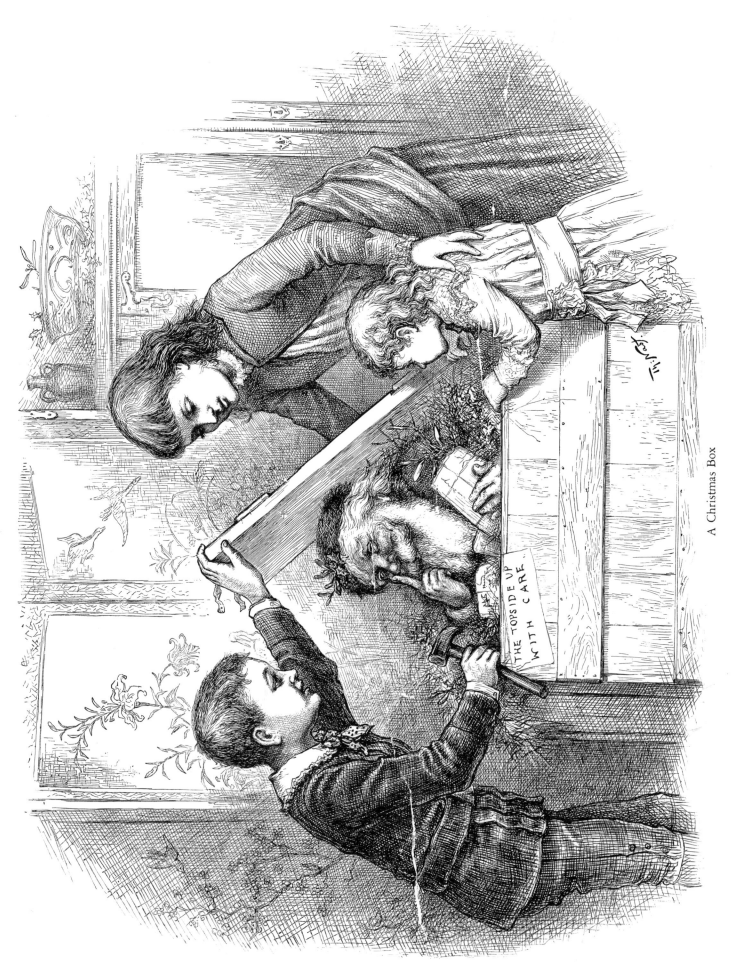

A Christmas Box

50

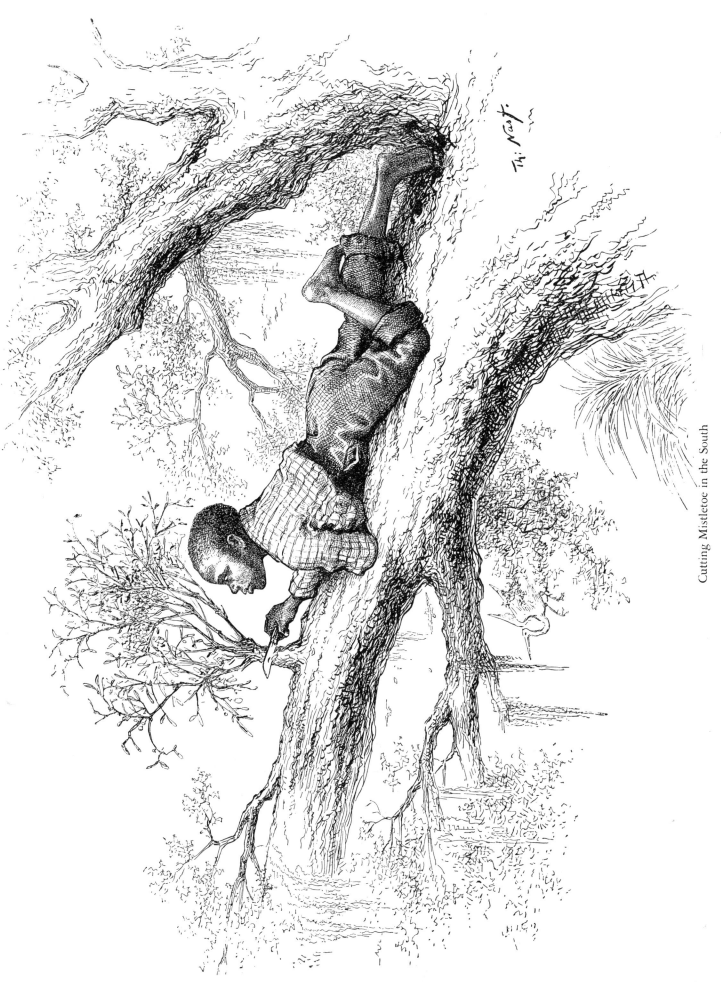

Cutting Mistletoe in the South

51

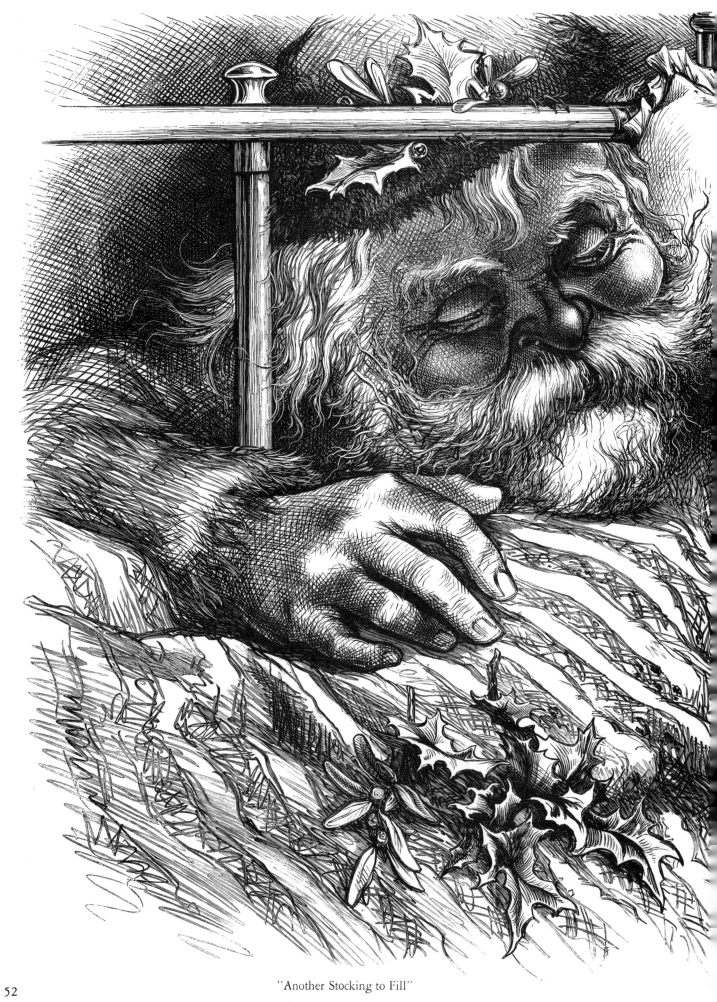

"Another Stocking to Fill"

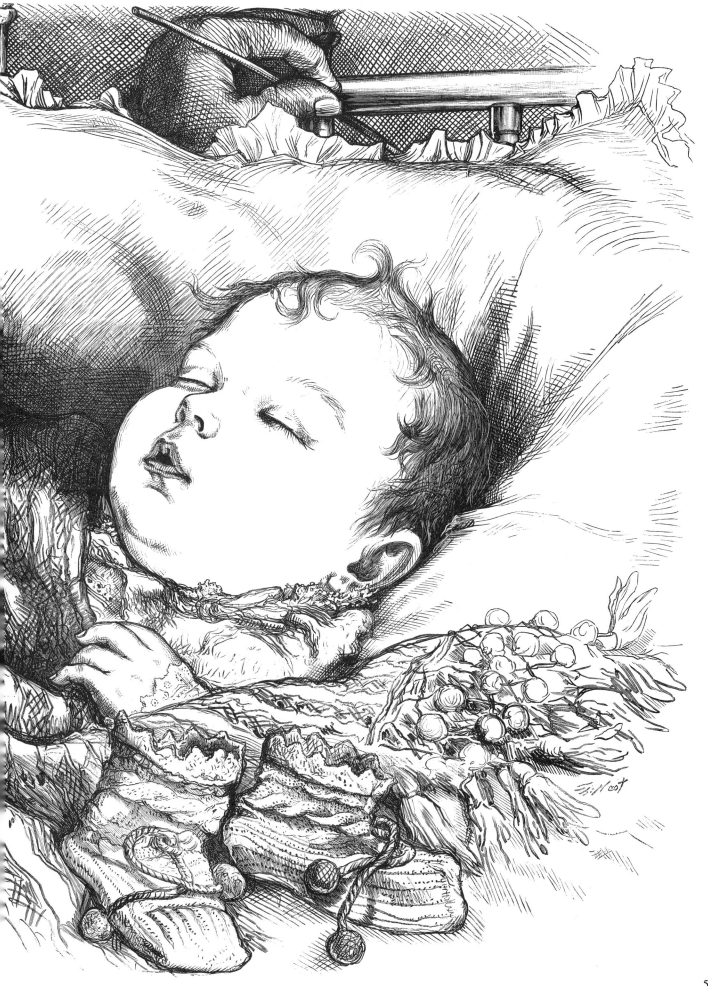

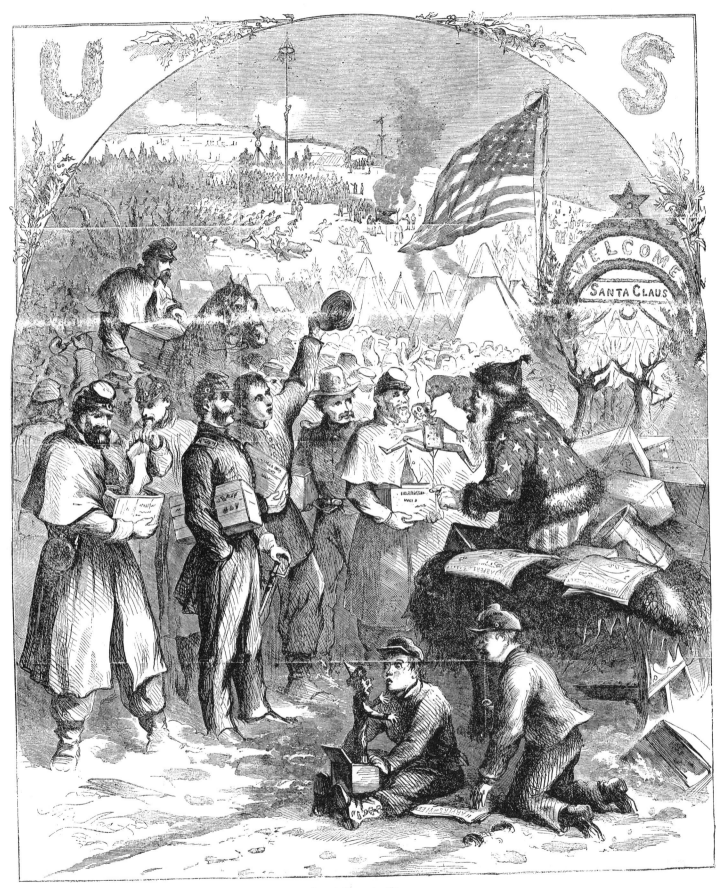

Santa Claus in Camp

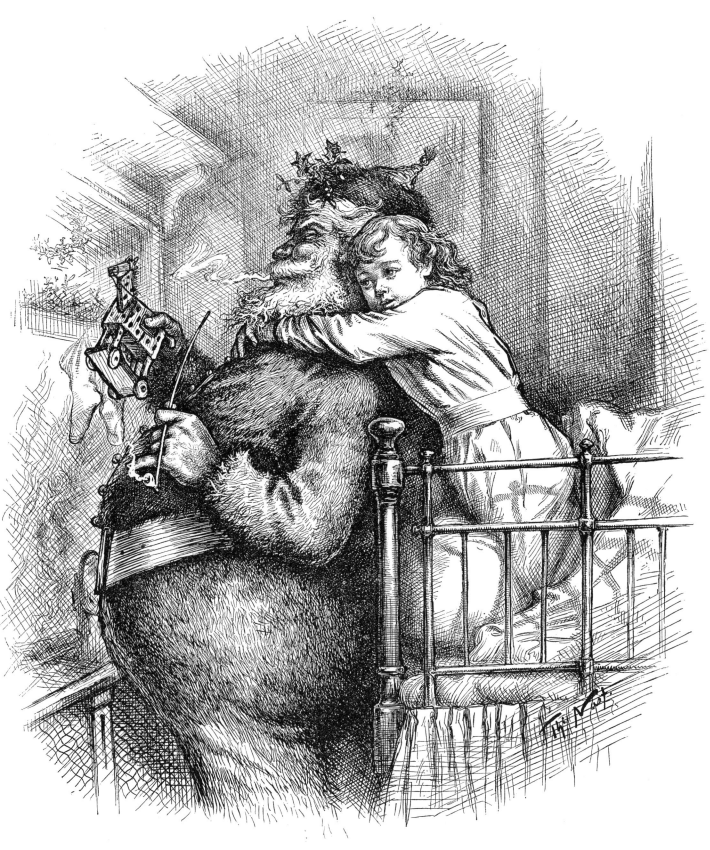

Caught!

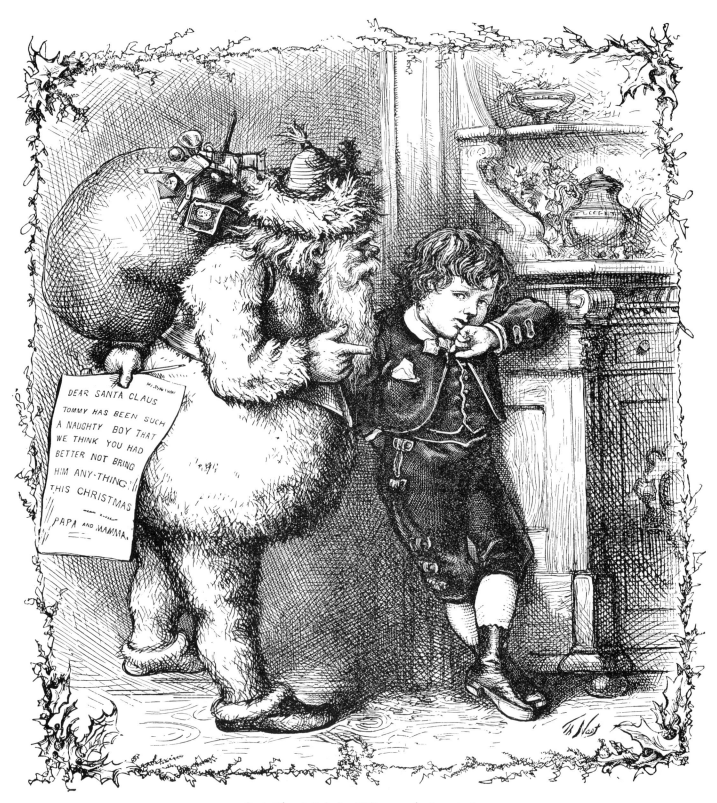

Santa Claus's Rebuke. "I'll never do it again."

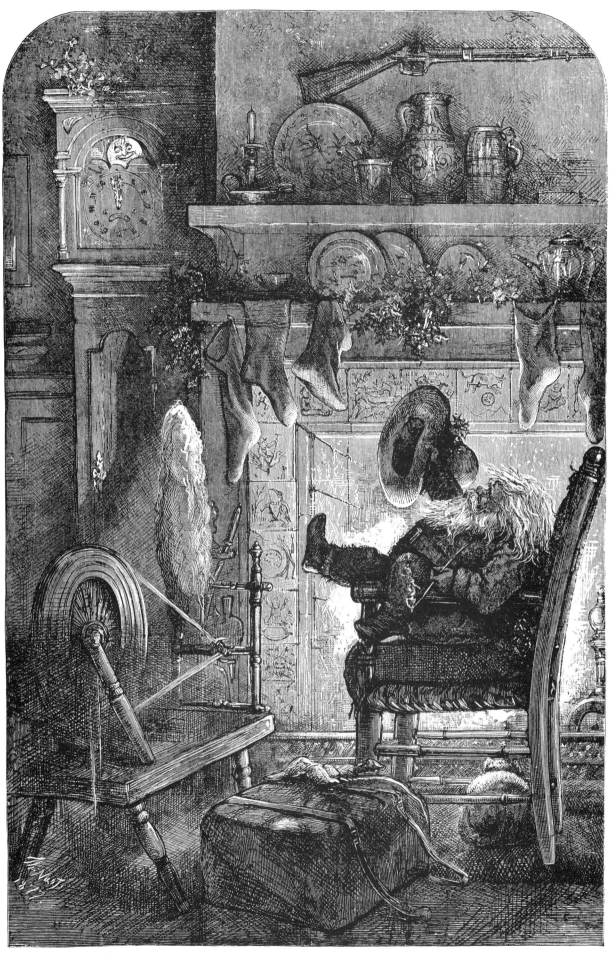

Christmas Eve—Old Faces for Young Hearts

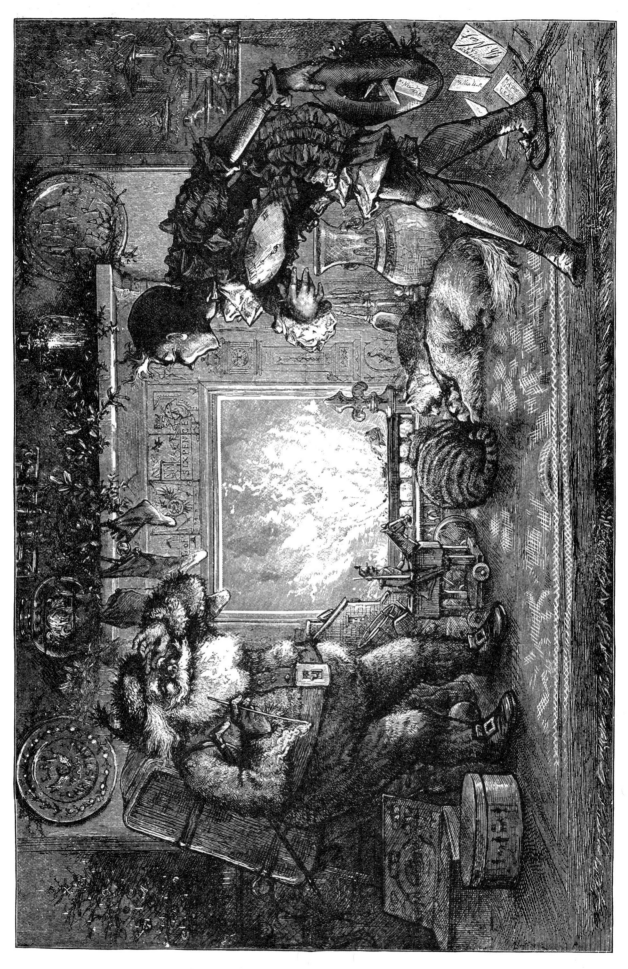

"Here we are again!"

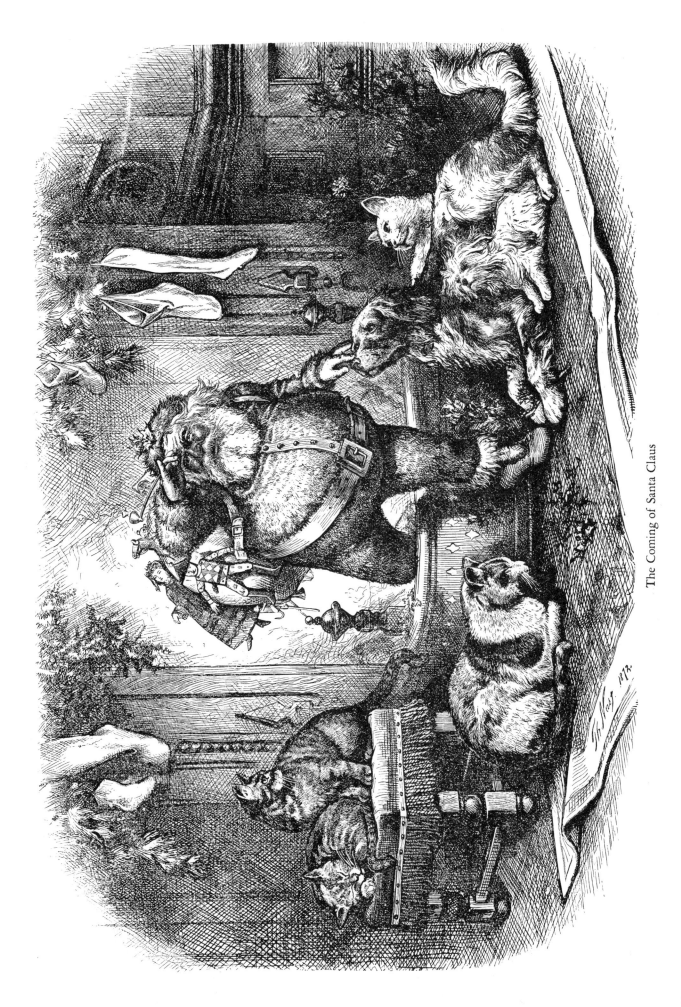

The Coming of Santa Claus

59

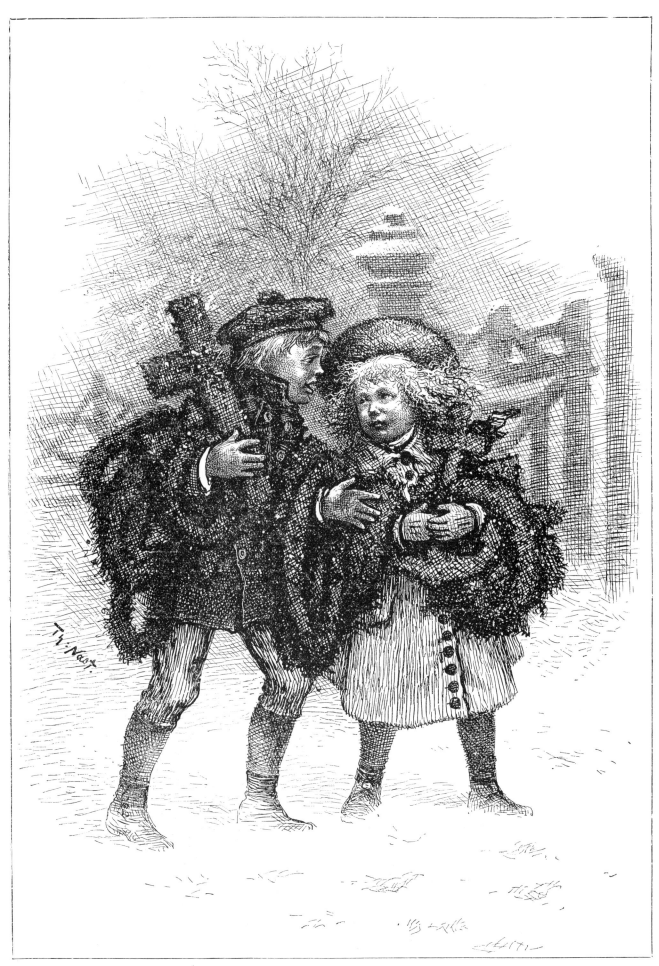

Christmas Greens

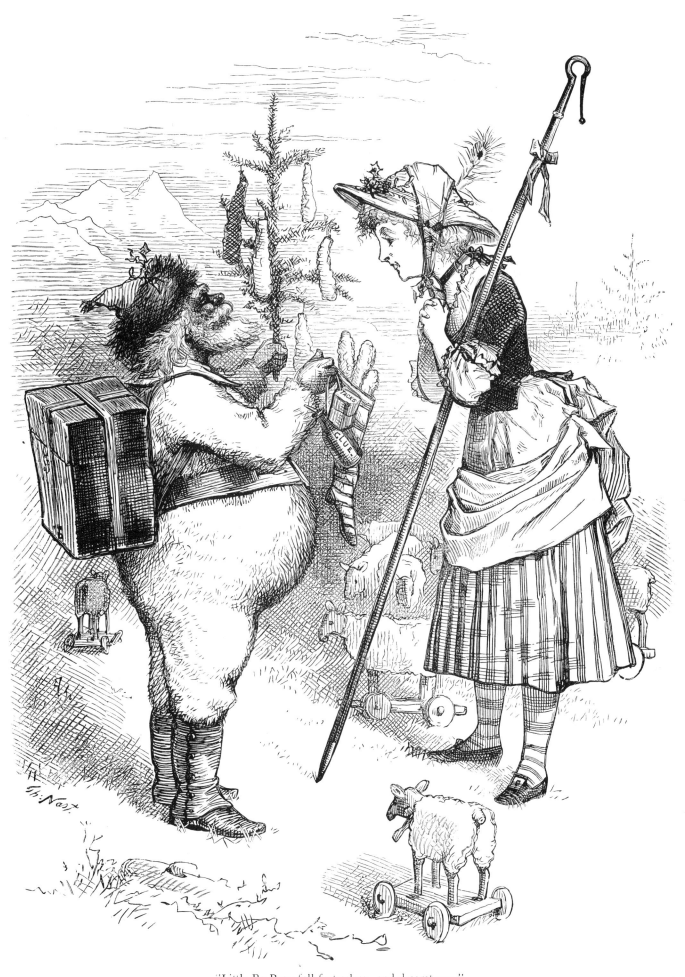

"Little Bo-Peep fell fast asleep, and dreamt——"

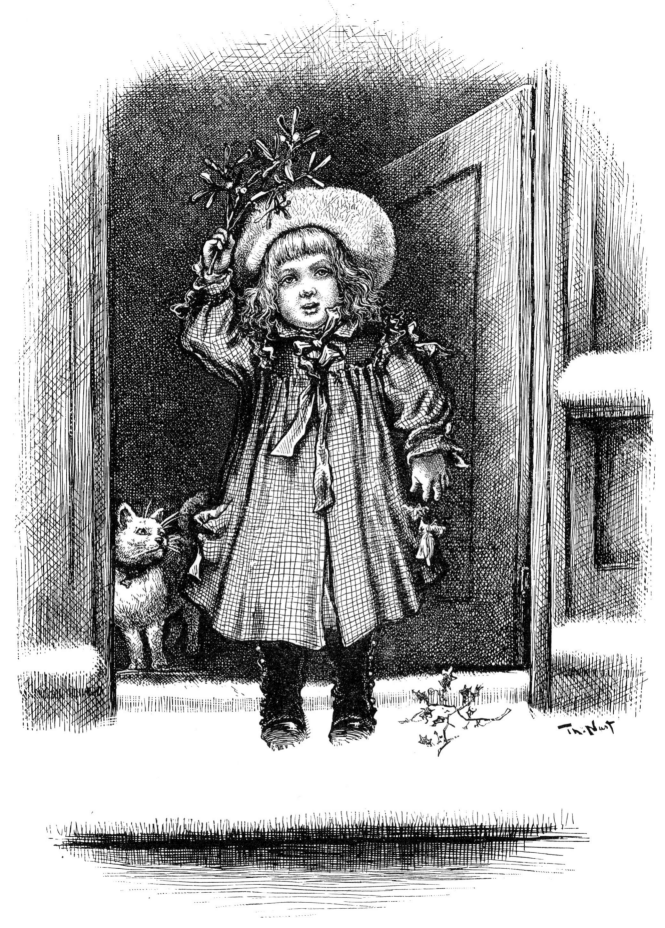

"Come now, Santa Claus, I's ready."

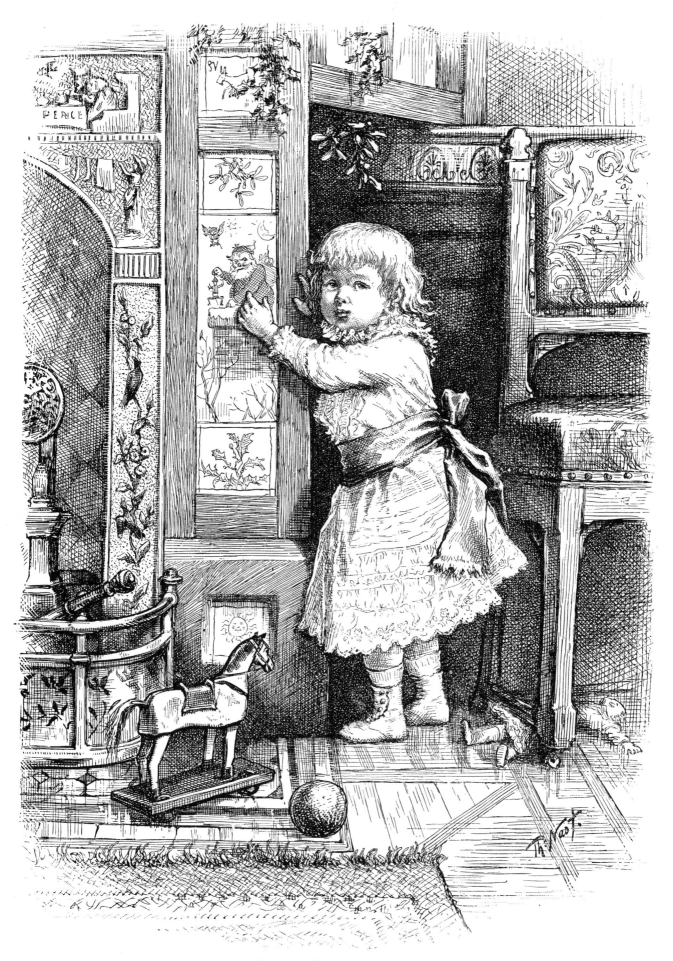

Nursery Tiles—"There he is."

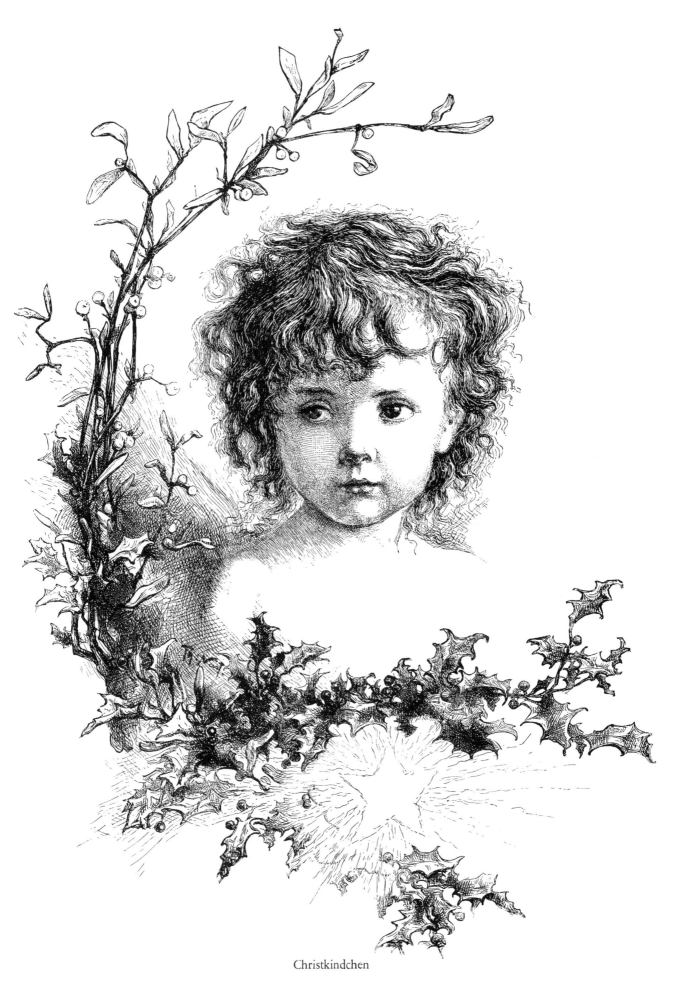

Christkindchen

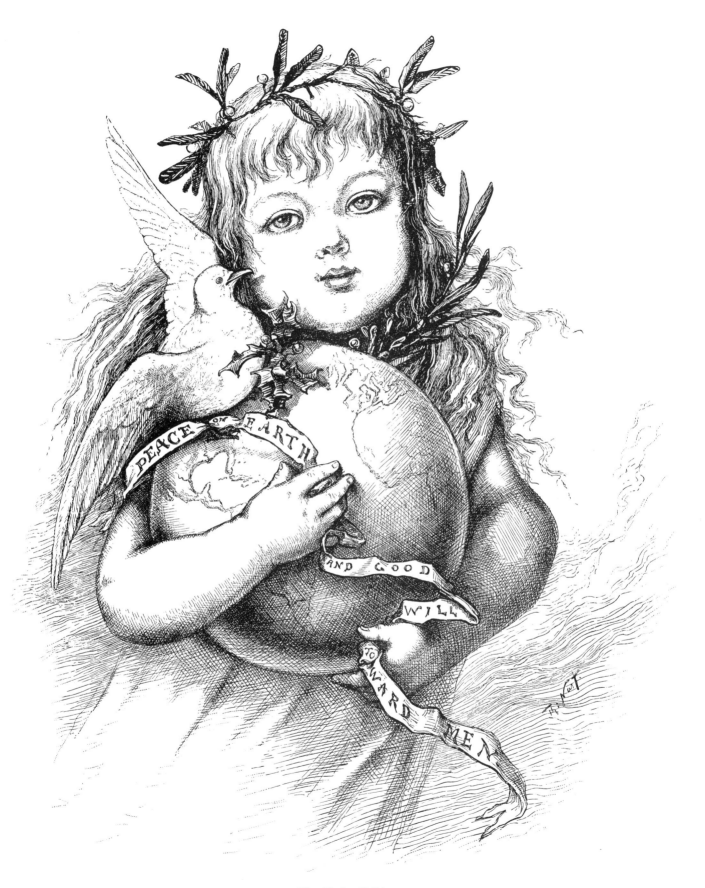

The Christ Child

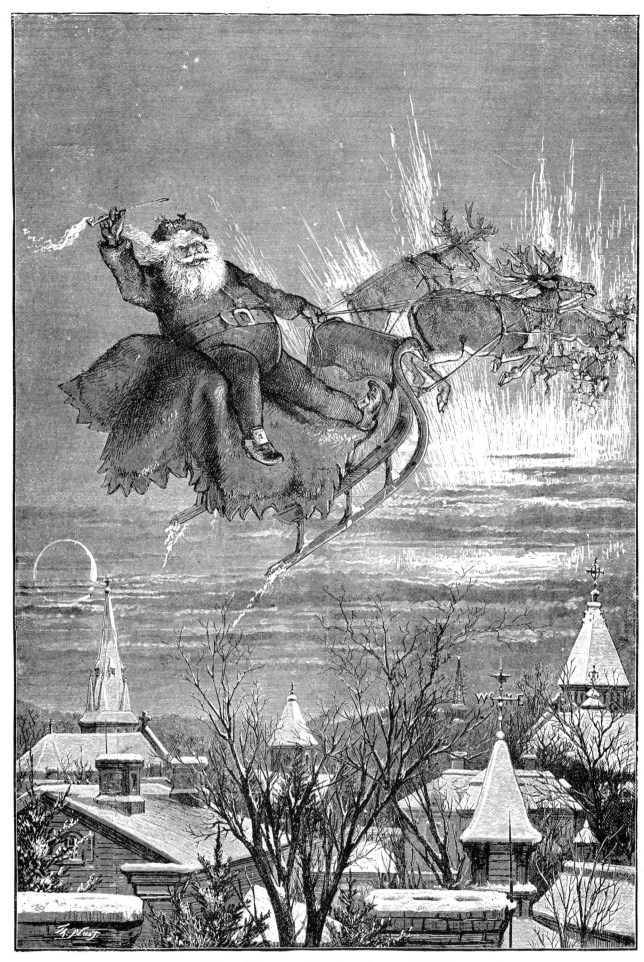

"Merry Christmas to all, and to all a good-night."

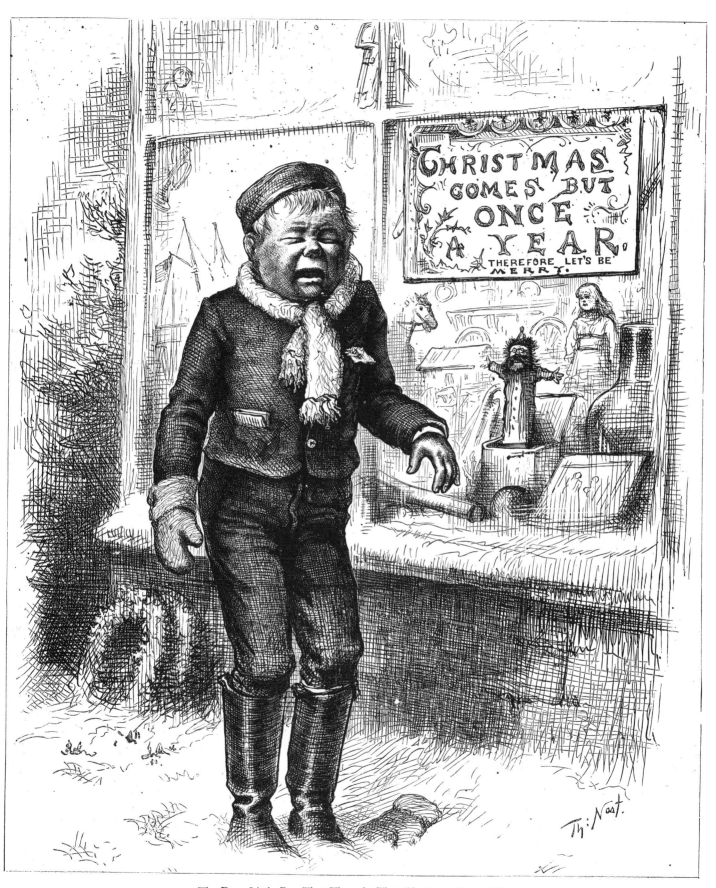

The Dear Little Boy That Thought That Christmas Came Oftener

"Who said anything about Christmas dinner?"

First-prize Christmas-card—Being Farthest from the Subject

DATE			